behind the silver screen

Hollywood Stills Photography from the 1930s to the 1950s

daniel herman

HERMES
PRESS

neshannock, pennsylvania

Photographs from the Hermes Press image library

Published by Hermes Press
2100 Wilmington Road
Neshannock, Pennsylvania 16105
(724) 652-0511
www.HermesPress.com; info@hermespress.com

Cover photograph: Audrey Hepburn, Bud Fraker, 1954
Cover and book design by Daniel Herman
Cover and book design ©2009 Hermes Press

First printing, 2009

LCCN 2008935002
ISBN 1-932563-16-4

Image scanning and digital corrections by H + G Media
Editor: Louise Geer
Proofreading: Margaret Sopkovich and Lori Geramita
From Dan, Louise, Sabrina, and D'zur for Gort and Maya

NOTE ON THE CAPTIONS: The captions in this book list the actor's and/or actress' name, then the photographer – if known – followed by the studio and date of release.

Hermes Press thanks and acknowledges the help of Profiles in History and its staff, together with Joe Maddalena, for generously lending the image of Grace Kelly which appears on page 130.

For my mother, Sandy Herman, who always loved the movies (and never got her big break) and for my Dad, Al Herman, who never tires of rewatching them

Printed in Hong Kong

4 introduction Hollywood Stills Photography from the 1930s to the 1950s

8 chapter one 1930s: The King of Hollywood; Platinum Blond; Gangsters and Swashbucklers; and Screwball Comedies

50 chapter two 1940s: Peek-a-Boo Bang; the Stuff Dreams are Made of; the War; Bogart and Bacall; and Film Noir

102 chapter three 1950s: Funny Face and Marilyn; Gort, Sci-fi, and Paranoia; the End of the Studios; and the Times, They Were a Changin'

142 index

contents

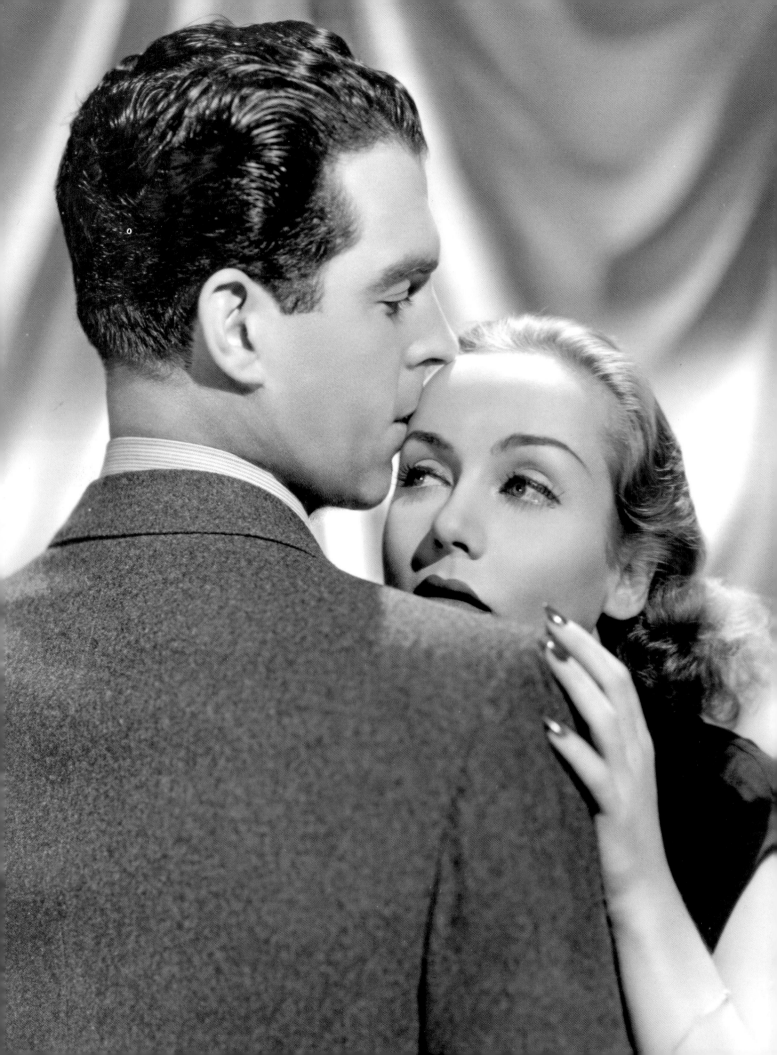

introduction

Hollywood Stills Photography from the 1930s to the 1950s

The portrait on the cover of this book, which very likely got you to pick up this volume in the first place, makes the point how effective Hollywood film photography could be in getting the attention of prospective film-goers, reeling them in, to buy tickets to the latest movie. The photograph in question, of Audrey Hepburn, was taken by one of Paramount's best photographers during the 1950s, Bud Fraker.

While not a lost art, film stills photography is not as important in the promotion of today's films as it was during the heyday of the great studios, the period from the 1930s through the end of the 1950s, the focus of this book. Today publicity for films is no longer dependant on eye-catching images of stars but rather on frenetic action and mayhem played out incessantly in ads shown constantly on television and the internet. Also, let's face it, films and their stars just aren't as glamorous and elegant as they were in the 1930s and 1940s; films can emulate

Carole Lombard and Fred MacMurry from *The Princess Comes Across*, Paramount, 1936.

this time but they can't ever recreate its spirit and visual style.

The photographs on view here were never intended by the studios to stand on their own, they were just another cog in the great Hollywood publicity machine. Make no mistake about it, the stills documented in this book were created for purely commercial purposes – the advertising and promotion of movies and their "stars." These photos found their way into the numerous pages of newspapers, fan and movie magazines and general circulation publications the like of *Time* magazine, *Look*, or *The Saturday Evening Post*. Just because Hollywood stills photography was grounded in the necessity to promote movies didn't limit the aspirations of the craftsmen involved and the end result, amply demonstrated by this book, is that their efforts far exceeded the demands of mere publicity.

During the period covered in this book all of the great studios – Columbia, 20th Century Fox, Metro-Goldwyn-Mayer, Paramount, RKO, United Artists, Universal, and Warner

Brothers – had stills departments. These small groups of photographers took literally hundreds, sometimes thousands, of pictures every day to document key scenes in the movies or "glamour" shots of the stars to reinforce their appeal to the masses of film-goers who crowded movie theaters to escape the great Depression and later as a welcome respite from the pressures of the Second World War.

This book will focus on two aspects of Hollywood stills photography, scene stills and portraits. Scene stills, as their name implies, were taken during filming or immediately after the word "cut" was announced by the director. The photographer would either capture the action of a scene as it was playing out during actual production or set up the scene and re-photograph it, which explains the difference between many scene stills and their counterparts in films. In some instances, most notably *King Kong* (1933), film stills images were created as a supplement to the film, which explains why many famous stills from this landmark effort never appear in the film.

Portrait photography for film stars was handled by another group of photographers, although many scene photographers doubled with portraiture, who during the 1930s created a distinct Hollywood style of "glamour" photography. This "style" was almost surreal; devoid of the clutter of the times, it was pristine, elegant and presented a sophisticated illusion film-goers could fantasize about during the dark years of the Depression. This style used stock poses of the great women stars of the era gazing upward in rapture while their male counterparts would usually stoically stare off-camera. These images are emblematic of "glamour" stills photography throughout the 1930s through the mid-1940s. Omni-present in many of these photographs is the classic prop from the era: the smoldering cigarette.

The recipe for achieving the effects in many of the portrait stills in this book was the creative use of lighting, sharp focus, and large cameras that utilized an 8 x 10 inch negative – imbuing many of these photos with nuanced tones and extremely fine detail.

Keep in mind that scene stills were an attempt to capture key images and moments from films, so many of the pictures in this book preserve images that typify the films they represent. As time has passed and these films have crept into pop-culture public consciousness, many of these stills have become emblematic of the films they memorialize. The image on page 54, of Agnes Moorehead in *The Magnificent Ambersons* (1942) is illustrative of how one photograph is able to concisely capture the emotional tone of a film. The photograph of John Garfield and Lana Turner from *The Postman Always Rings Twice* (1946) on page 91 is an archetypal film noir image that on one hand captures the mood of the film but also sums up many key aspects of the whole genre as well.

This book is divided into three chapters, each spanning a decade. The films represented run the gamut of what Hollywood had to offer, ranging from screw-ball comedies to serious drama; from the light-hearted films of Fred Astaire to such science-fiction classics as *The Day the Earth Stood Still* (1951) and *Invasion of the Body Snatchers* (1956). The portrait stills on display in these pages also present a wide range of Hollywood's greatest stars by some of the most noteworthy photographers to work for the studios during the thirty-year period covered in this volume. Indeed, many of these portraits have been reproduced so often that they are universally identified with their subjects.

Before the mid-1970s the photographers whose efforts are highlighted here were given little consideration or credit for their work except among knowledgeable collectors and film historians.

When most of these photographers were active they were well known to the stars they photographed, to film directors, art directors, publicists, and in the Hollywood community,

but not outside the hermetic world of southern California. Today many of these artists, who worked with camera, film, light, and shadow, are given equal consideration among the top ranks of 20th century photographers. This volume will present the work of many of these photographers and focuses on both the well-known and less-known practitioners of this specialized craft.

The great Hollywood publicity factories reinforced the images of stars with a constant barrage of photos and helped try to build public awareness of up-and-coming stars in the same way. Some made it big, others did not, but the surviving portraits of Hollywood's footnotes are a memorable and handsome testament to the aspiring actors and actresses who never quite gained full "star" status.

The studios also used portrait stills to create a public perception of their stars and instill an image of an actor or actress that would "register" with the audience.

Joan Crawford is frequently credited with using her portrait stills to change the public's perception of her from a flapper to a serious romantic leading lady.

Another well-known example of an actress whose persona was molded and shaped by stills photography is Marlene Dietrich. When Dietrich arrived in the United States she was sensually beautiful but not exotic. Under the tutelage of director Josef von Sternberg, Dietrich's image was shaped and formed into what became her screen persona through the aid of her publicity photographs. The portrait stills of Dietrich shot from 1930 through 1935 clearly attest to this genesis and are another example of how film stills augmented what was on the screen to help further mold the film-going public's perception of what a "star" personified. The photograph on page 18, by Eugene R. Richee, from *Dishonored* (1931), is an example of a portrait taken under the supervision of von Sternberg, which gives a clear idea of the persona being developed for Dietrich.

As the times changed and the Depression gave way to the Second World War, "classic" portrait photographs reacted to the very different tone of film noir, then again changing to accommodate the atmosphere witnessed in the 1950s, and finally the up-beat tone at the end of the baby boom in the late 1950s.

The images in this book were taken directly from the original photographs issued by the studios. Some of them were sent to newspapers and magazines for use in publicity, others went to theater owners to put in their lobbies, while others were saved by studio employees or found their way into the hands of fans and collectors. As many of these photographs are over seventy years old, they are not in perfect condition, so forgive the stray scratches, marks, bends, and folds in evidence on these stills.

The photographs in this book are much more than mere nostalgia, they represent a fusion of art and craft which when viewed over seventy years since their creation still stand as objects of beauty and élan. The portraits and scene stills the subject of this book are a testament to how the best artisans working in the great film factories of Hollywood were able to transcend the drudgery of the daily pressures of producing "just a product for commerce" and to crystallize, on film, representations of a time and style long gone, but not forgotten.

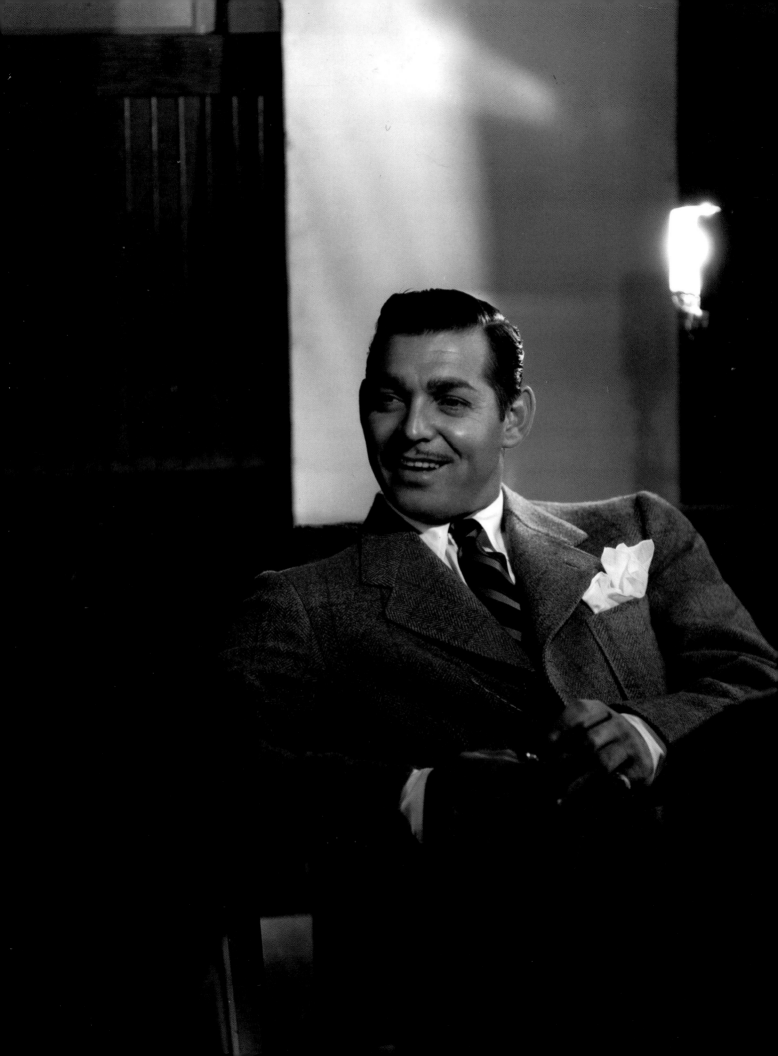

chapter one

1930s: The King of Hollywood; Platinum Blond; Gangsters and Swashbucklers; and Screwball Comedies

In 1927 the American public was introduced to the "talkies." This event, satirized and commemorated by Gene Kelly and Stanley Donen's *Singin' in the Rain* (1952), permanently changed more than what was required of actors, it demanded a complete rewrite on the creation and the promotion of movies.

The advent of sound and the solidification of the studio system, of big institutional film factories, started a crystallization of just how film stills photography could be used to promote the "products" being created by Hollywood. The style, look and "feel" of these photos were changing as well.

The popularization of silent movies during the second decade of the 20th century saw the necessity for still photographs of scenes from the "moving-pictures" to be used in advertising to get the public interested in the films being promoed, as well as their actors. Instead of shooting photographs of the scenes however, frequently frames from the actual movie film stock were just "blown up." The result was stills that lacked sharpness and depth, and, were pretty unattractive. The solution was simple, have someone on the set during filming and have him take photos during "key" scenes. Initially, scene stills photographers were drafted from the ranks of assistant cameramen that populated silent film crews.

Among those who started as assistant cameramen and became well-known and influential film stills photographers included Clarence Sinclair Bull, Robert Coburn, Madison Lacy, and Eugene R. (E. R.) Richee. The practical experience, learned "on the job," by these early film photographers proved invaluable in producing work that captured the essence of a film scene in one shot. It should be remembered that, on occasion, literally dozens of exposures were taken of each scene from which the most representative were culled and printed for promotional and publicity purposes.

The art of studio/portrait photography was also developing a recognizable style during the

Clark Gable, Clarence Sinclair Bull, 1937.

decade covered by this chapter. The portraits of the silent film era had a diffuse focus whereas the style that developed during the 1930s emphasized sharp focus complemented by extremely bright overhead or "key" lighting – mounted on a boom. The use of long lenses, large 8 x 10 inch negatives, and massively bright lighting were all part of the recipe used to create what is commonly perceived as classic Hollywood portraits. This style was developed and championed most notably by, amongst others, George Hurrell, Clarence Sinclair Bull, E. R. Richee, Ernest Bachrach, Robert Coburn, and Laszlo Willinger.

Because the photographs in this volume were shot on constant deadlines, under enormous pressure to "get it done, and fast," it is often difficult to really know exactly who did what. The style of Hollywood glamour photography was easily absorbed and copied by the many talented photographers working in the studio system. Indeed, one famous picture of Clark Gable usually attributed to George Hurrell was actually taken by another noted practitioner of cinematic portrait photography, Harvey White. The manner most frequently used to identify a photographer, other than with well known images attributed to a certain artist, is simply to look on the back of the photograph and read the rubber-inked stamp identifying who should be given credit.

The era of the Depression was a time when movie-goers were presented with screwball comedies, tales of gangsters, swashbucklers, and high Hollywood style; after all, how better to escape from the realities of a collapsed economy and high unemployment?

The photographers charged with capturing the milieu of this cinematic time included: Clarence Sinclair Bull, George Hurrell, Laszlo Willinger, Virgil Apger, Ted Allan, and Eric Carpenter at MGM; A. L. "Whitey" Schafer at Columbia; Frank Powolny at 20th Century Fox; E. R. Richee, Otto Dyar, William Walling, and John Engstead at Paramount; Ernest Bachrach, Robert Coburn, Gaston Longet, John Miehle, and Alex Kahle at RKO; Jack Freulich and Ray Jones at Universal; and Elmer Fryer, Scotty Welbourne, Bert Longworth, Bert Six, Madison Lacy, Irving Lippman, and Mucky Munkacsi at Warner Brothers.

The first illustration in this chapter, appropriately enough, features a relaxed Clark Gable. Gable was elected, in a popularity poll, the "King of Hollywood," and in this particular portrait was photographed by the head of MGM's stills department, Clarence Sinclair Bull. Unlike many of the posed glamour shots of the period, Gable looks like a real person; instead of the heavy retouching used in many portraits this photograph gives the King presence and real down-to-earth personality.

Bull was an extraordinary photographer whose skill developed and matured during the 1930s, and well into the 1950s. Note the diversity and range of his work in this chapter, from the photo of Gable and Jean Harlow for *Wife vs. Secretary* (1936) on page 13, to his portrait of Greta Garbo from *As You Desire Me* (1932) on page 29, and finally to his study of Myrna Loy and William Powell from *Double Weddings* (1937) on pages 38-39.

Bull was hired by Samuel Goldwyn in 1924 to shoot portraits of his stars; when the company merged with MGM he stayed on taking the responsibility of running the stills department until his retirement in 1959. He photographed thousands of actors and actresses but is best known for being Greta Garbo's personal favorite portraitist; it is accordingly obvious why his biography was entitled *The Man Who Shot Garbo.*

Bull was an excellent example of an all-around professional who understood his craft and could always provide a photograph that would properly represent the subject.

Also in the top ranks of Hollywood photographers during the 1930s were Ernest Bachrach, Robert Coburn, E. R. Richee, and Laszlo Willinger. Bachrach was the head of

RKO's stills department from its creation in 1929 until the end of the 1950s. His portraits, rather than being merely a repetition of stock poses or being formulaic, embrace and enhance the personalities of their subjects. Illustrative of this point is Bachrach's portrait of Fred Astaire on page 23.

Robert Coburn, who apprenticed under Bachrach at RKO, commented once that, "He (Bachrach) could do anything photographic. So it rubbed off on me." Coburn went on to head Samuel Goldwyn's stills department in 1936 and later spent many years at Columbia Pictures as we shall see in the later chapters of this book.

E. R. Richee ran the stills department at Paramount, a position he obtained with the help of his friend Clarence Sinclair Bull. Richee photographed all the major stars at Paramount, as the portraits on pages 18, 31, 33, and 46 amply demonstrate. He left Paramount in 1941, succeeded by A. L. "Whitey" Schafer, and took up shop first at MGM and later at Warner Brothers.

Willinger, who was already an established photographer in Europe when he came to the U.S., hung his hat at MGM in 1937. Willinger's work was distinguished by unusual, creative lighting and a knack for placing his subjects in unusual ways that looked "just right." He understood the dramatic and the elegant, and both of these qualities always came through in his work. Unlike most of his peers, Willinger frequently used a hand-held camera instead of relying on the bulky behemoths commonly used. His work never suffers from the often static quality of portraits from the era; Willinger was able to achieve set-ups of his subjects which were more dynamic and rigorously theatrical.

Another photographer who helped define the style of Hollywood portrait photography and is inseparably associated with high fashion/concept portraiture was George Hurrell. Hurrell studied painting and graphics at the Art Institute of Chicago and then at the Academy of Fine

Arts but dropped out to work at a succession of photography studios. He headed west in 1925 and by 1929 had established himself as a professional photographer. Hurrell began to find lucrative work as an independent portrait photographer for a number of stars including actress Norma Shearer, whose husband was Irving Thalberg, the head of MGM. As a result of this connection, coupled with Hurrell's knack for injecting a high fashion sense of style into his work, he was hired by MGM beginning in 1930. His tenure there lasted for a little less than two years. Hurrell's work was distinguished by his subjects' surreal detachment; the actors and actresses Hurrell photographed usually seem to be transfixed in deep contemplation all the while being bathed in multi-silver-toned grays and blacks. The photographs of Bette Davis on page 36, Norma Shearer on page 37, and Joan Crawford and Spencer Tracy on page 45, are all textbook examples of the Hurrell style. Hurrell developed productive relationships with Shearer and Crawford creating a significant body of work representing these two actresses. Hurrell's work is primarily limited to portraiture and after he developed his style he rarely deviated from it, hence his work has a predictable and sometimes antiseptic quality about it.

All of these photographers helped define, through their stills, our photographic recollection of the films of the 1930s. This period, which gave the public movies that range from *Charlie Chan at the Opera* (1936) to *Stage Coach* (1939); from the like of *The Public Enemy* (1931), *Top Hat* (1935), *A Day at the Races* (1937), *The Thin Man* (1934), *Topper* (1937), *My Man Godfrey* (1936), *It Happened One Night* (1934), and *The Adventures of Robin Hood* (1938) helped set the standard for a number of archetypal characters and stories which have a style and feel which has rarely been equaled since.

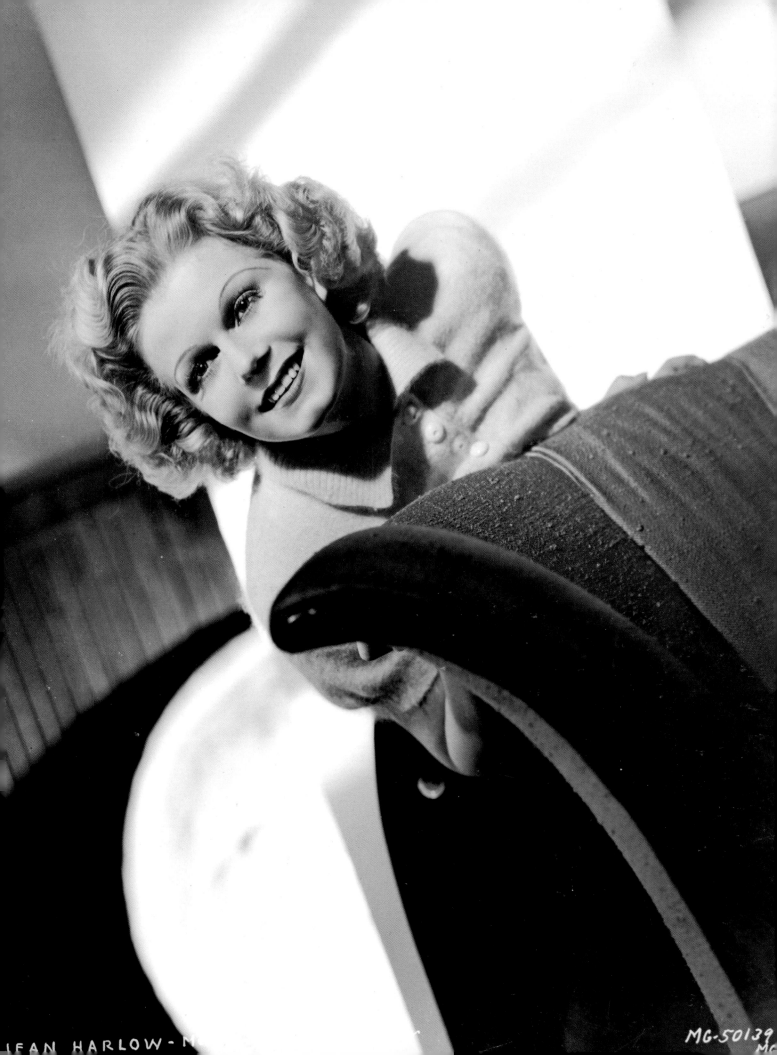

MG-50139

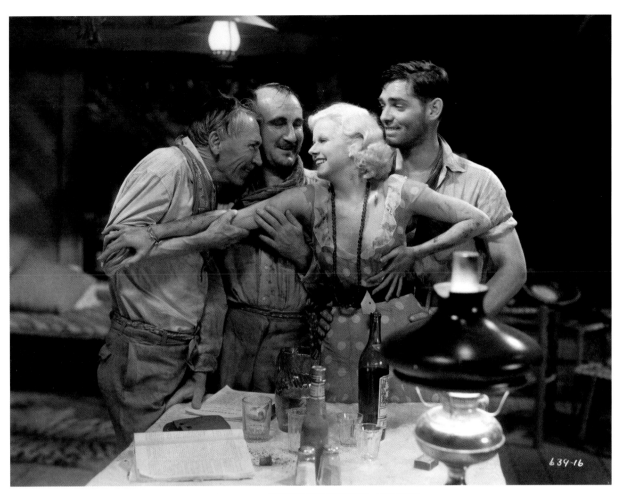

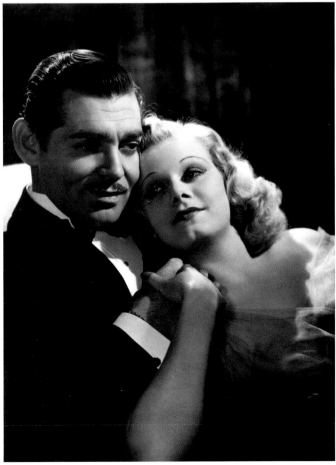

Opposite page: Jean Harlow, Ted Allan. Harlow was often referred to as the "Platinum Blonde," for obvious reasons. Above: Clark Gable and Jean Harlow, *Red Dust*, MGM, 1932. Left: Clark Gable and Jean Harlow, Clarence Sinclair Bull, from *Wife vs. Secretary*, MGM, 1936.

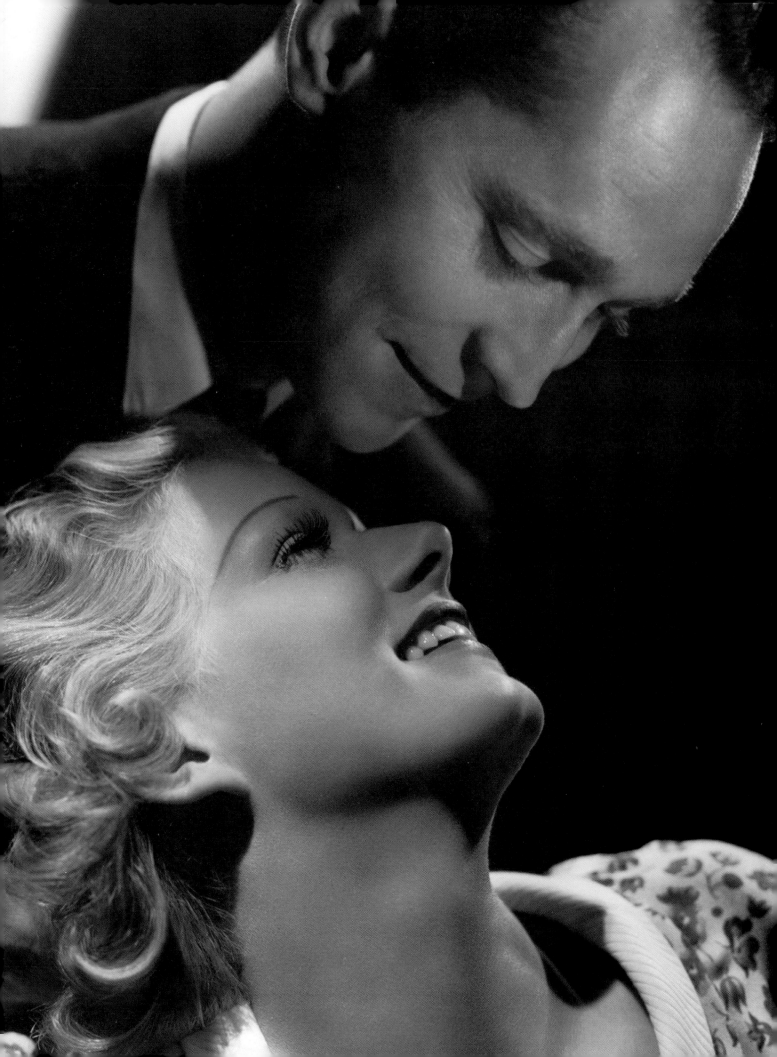

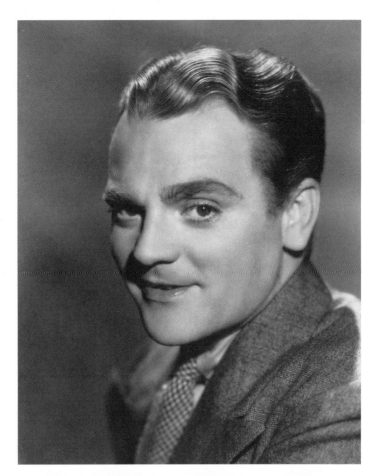

Top: Jimmy Cagney, Scotty Welbourne. Bottom: Jean Harlow, Jimmy Cagney and
Edward Woods, from *The Public Enemy,* Warner Brothers, 1931. Opposite page:
Jean Harlow and Frachot Tone, Ted Allan, from *Suzy,* MGM, 1936.

Overleaf: Jimmy Cagney and Edward Woods, from *The Public Enemy.* This still rec-
reates a key scene where Cagney's best friend (Woods) is killed in broad daylight on
an open street – a shocking scene at the time.

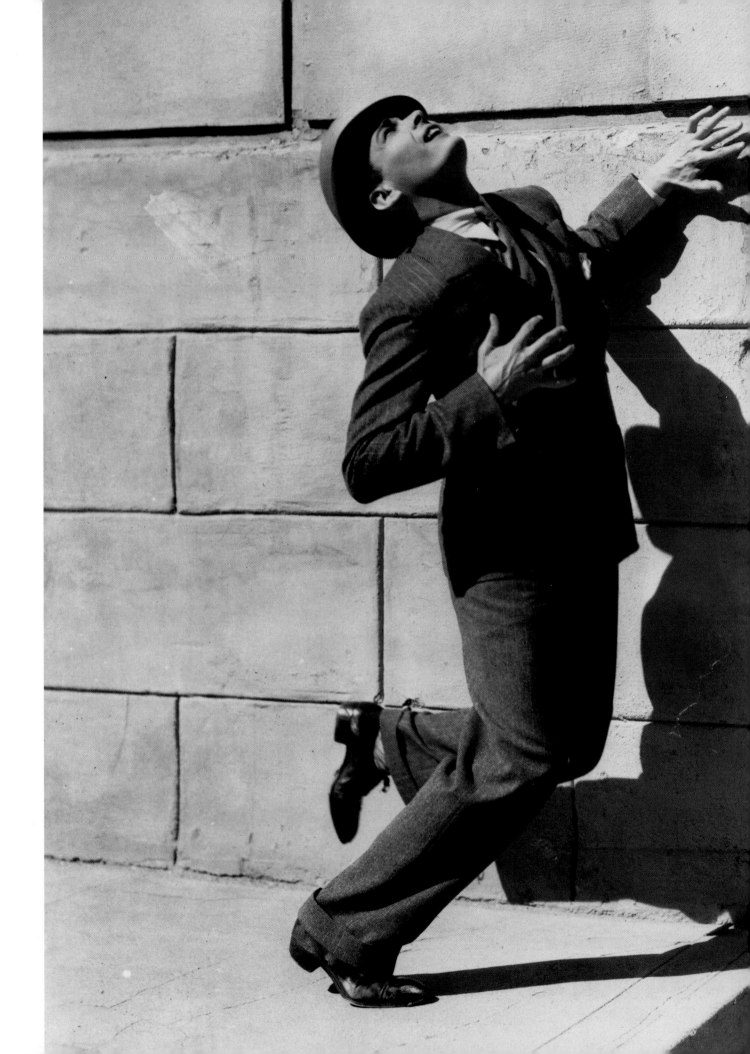

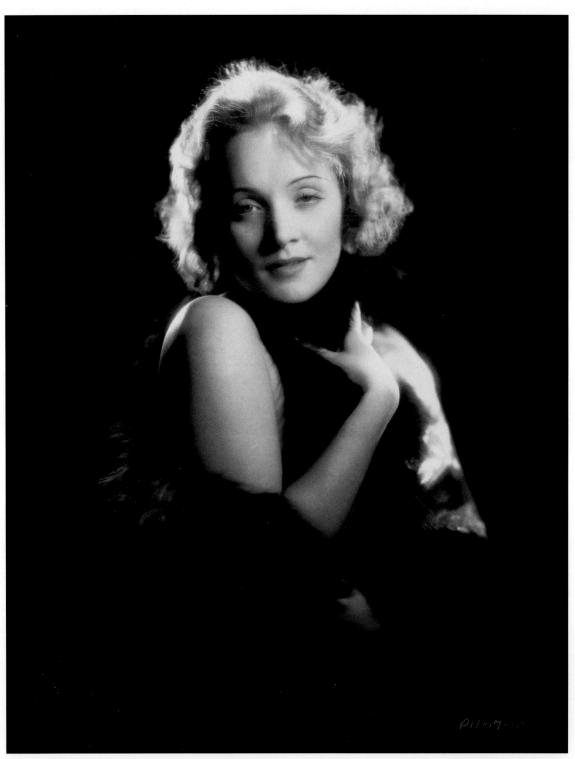

Top: Marlene Dietrich, E. R. Richee, from *Dishonored*, Paramount, 1931. Opposite page: Sylvia Sidney, 1938.

P/230-934

Above: Jean Parker from *The Barrier*, Paramount, 1937. Right: Binnie Barnes, 1938. Opposite page: Kay Francis, Otto Dyar.

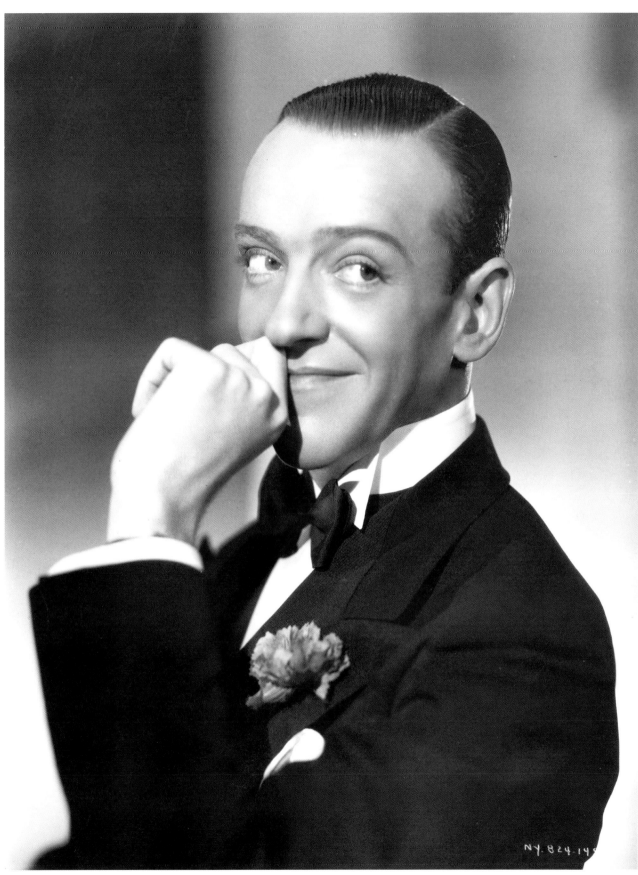

NY 824 14

Opposite page: Fred Astarie and Ginger Rogers, RKO, 1934.
Above: Fred Astaire, Ernest Bachrach, from *Top Hat*, RKO, 1935.

1930s: The King of Hollywood; Platinum Blond; Gangsters and Swashbucklers; and Screwball Comedies

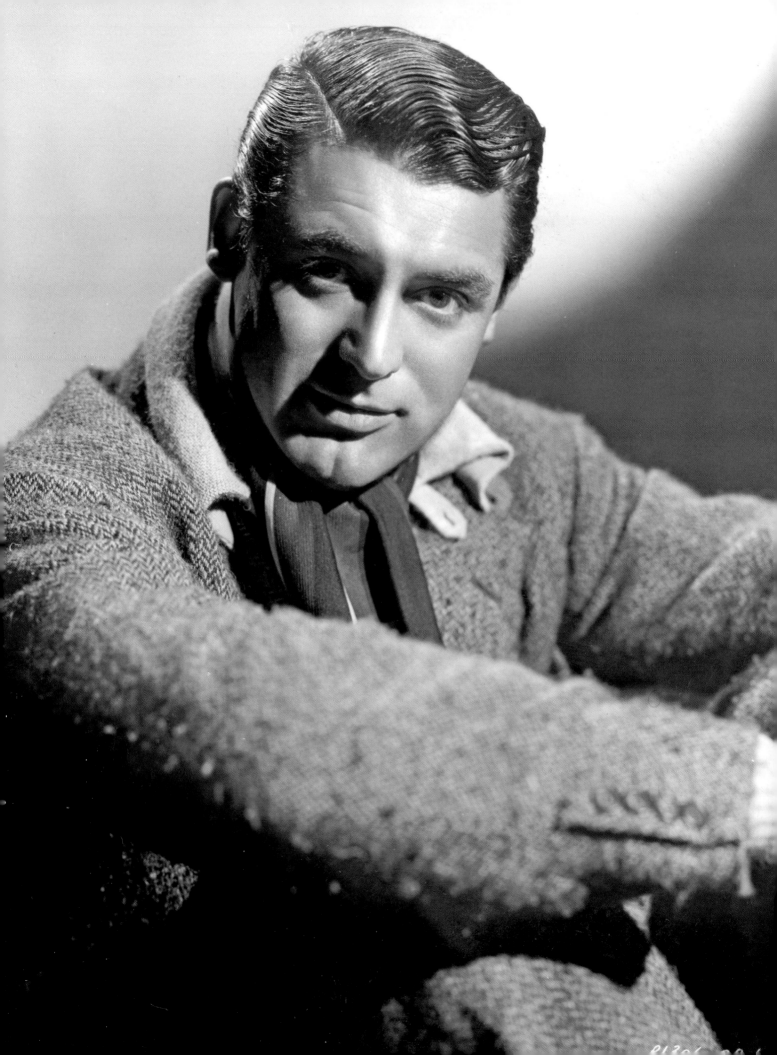

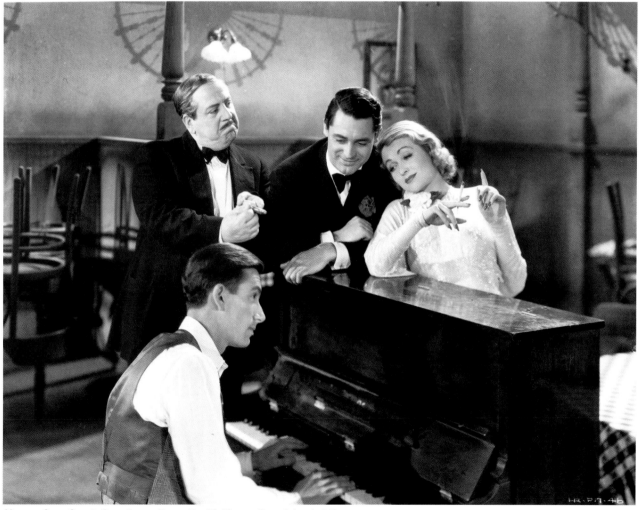

Above: Cary Grant, Constance Bennett with Hoagy Carmichael at the piano, from *Topper*, MGM, 1937. Opposite page: Cary Grant, 1936.

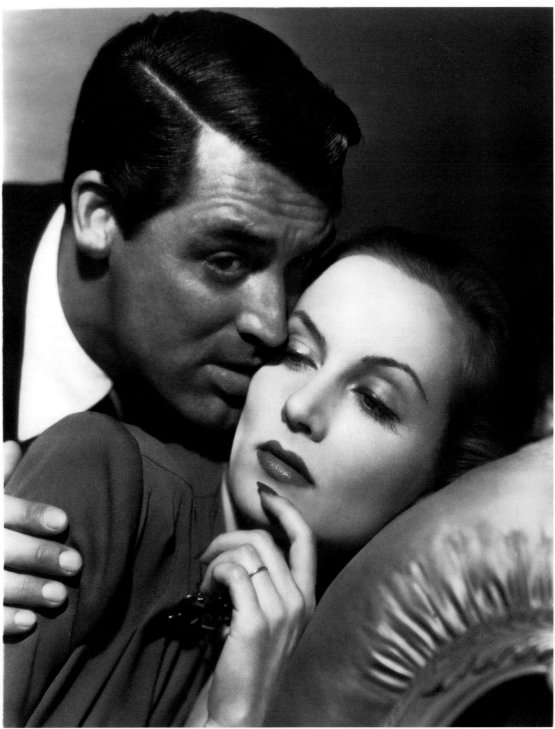

Above: Cary Grant and Carole Lombard, Ernest Bachrach, from *In Name Only*, RKO,
1939. Opposite page: Carole Lombard, Scotty Welbourne.

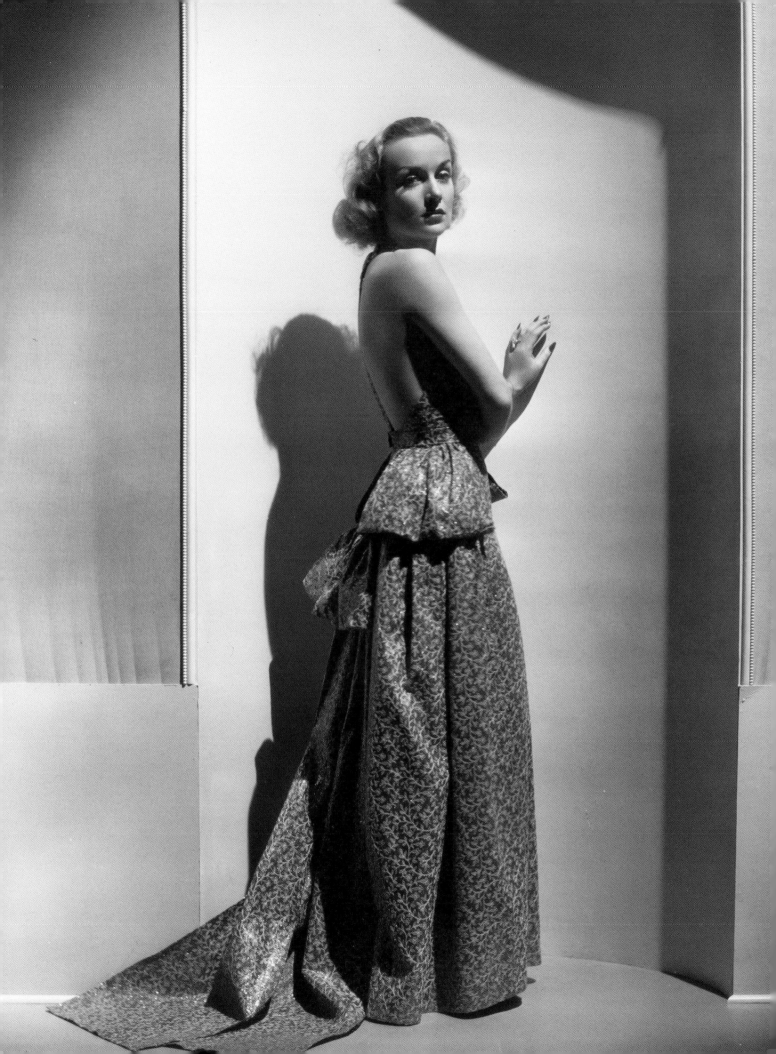

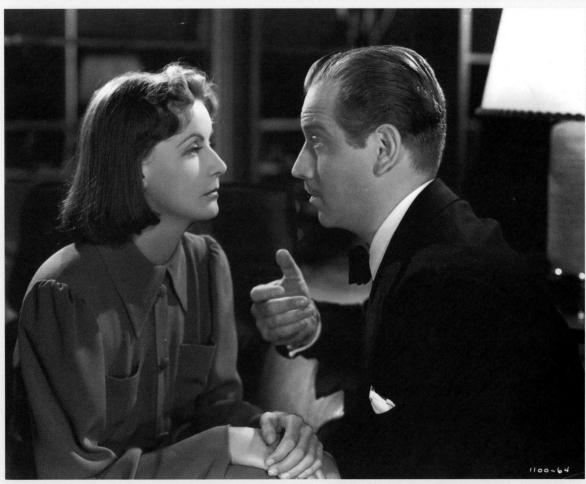

Above: Greta Garbo and Melvyn Douglas, Milton Brown (one of the few photographers Garbo would permit to photograph her other than Clarence Sinclair Bull), from *Ninotchka*, MGM, 1939. Opposite page: Greta Garbo, Clarence Sinclair Bull, *As You Desire Me*, MGM, 1932.

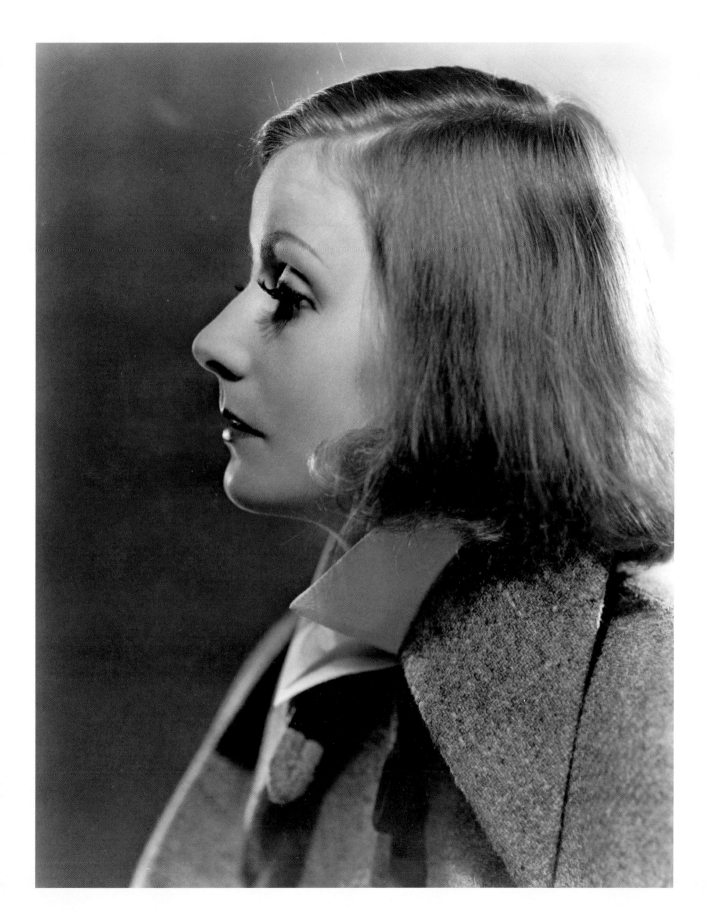

1930s: The King of Hollywood; Platinum Blond; Gangsters and Swashbucklers; and Screwball Comedies

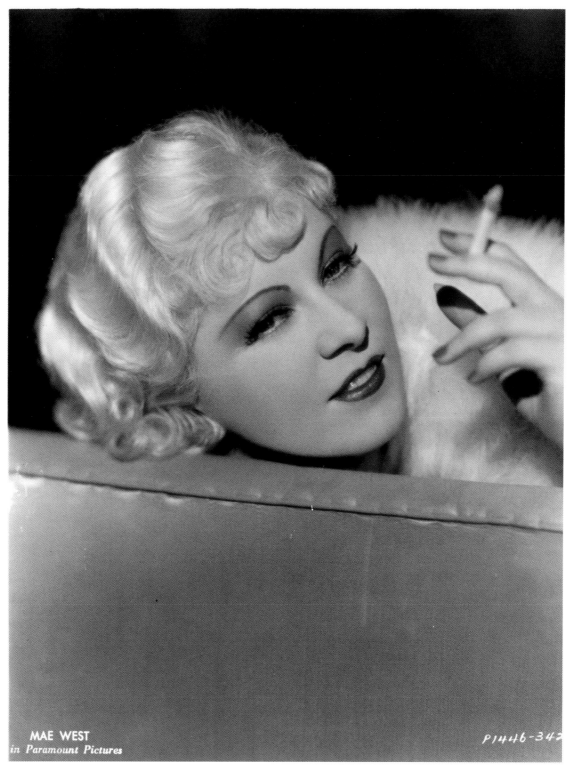

MAE WEST
in Paramount Pictures

P1446-34?

Above: Mae West, E. R. Richee. Opposite page: Irene Dunne, 1933.

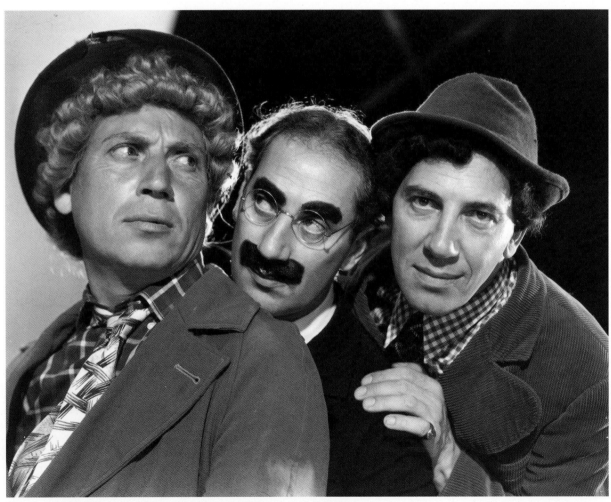

Above: the Marx Brothers, Harpo, Groucho, and Chico, from *A Day at the Races*, MGM, 1937. Opposite page: Francis Dee, E. R. Richee, 1937.

Above: Shirley Grey, Irving Lippman. Opposite page: Fay Wray, A. L. "Whitey" Schafer.

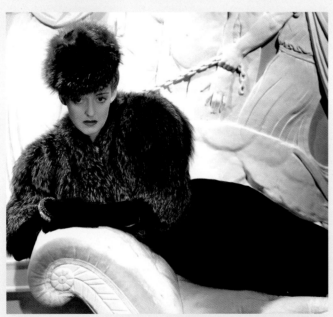

Above: Lana Turner (center), Anita Louise, Mary Beth Hughes, Jane Bryan, Marsha Hunt, and Ann Rutherford from *These Glamour Girls*, MGM, 1939. Below: Bette Davis, George Hurrell, from *Dark Victory*, Warner Brothers, 1939. Opposite page: Norma Shearer, George Hurrell.

Overleaf: Myrna Loy and William Powell, Clarence Sinclair Bull, from *Double Weddings*, MGM, 1937.

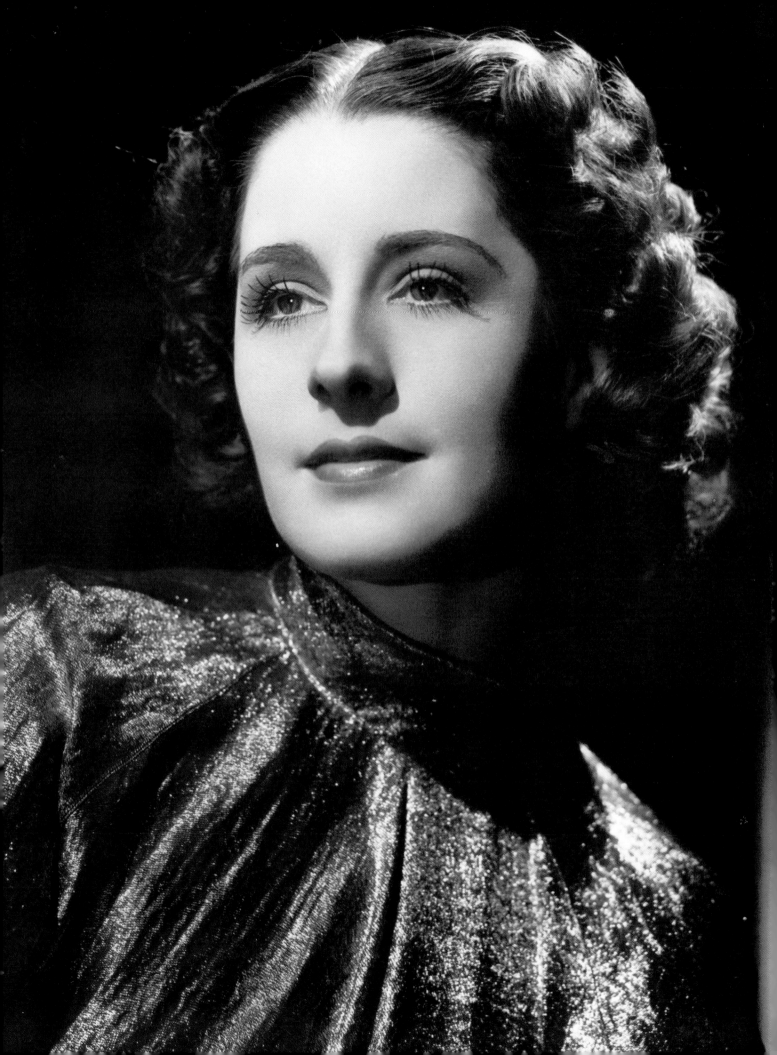

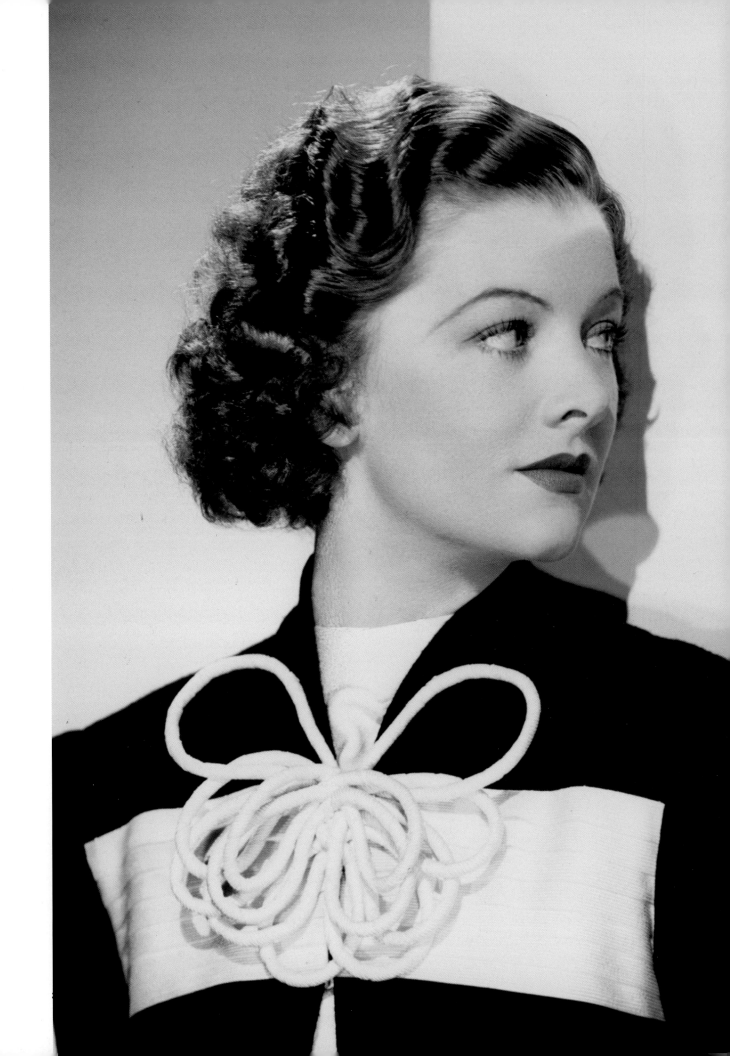

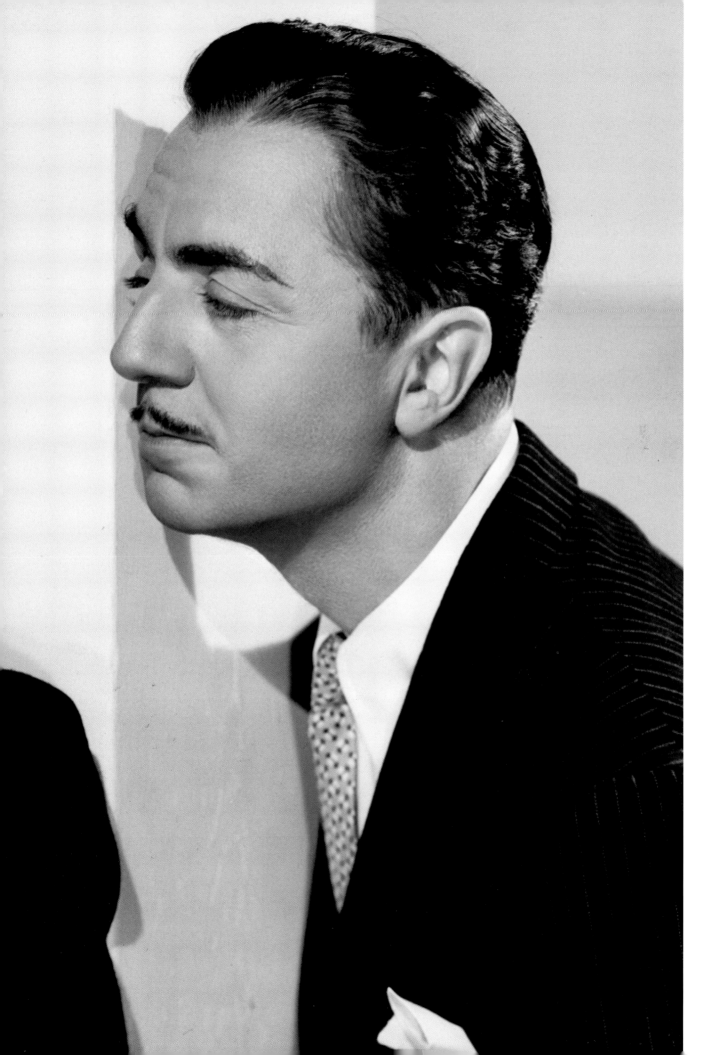

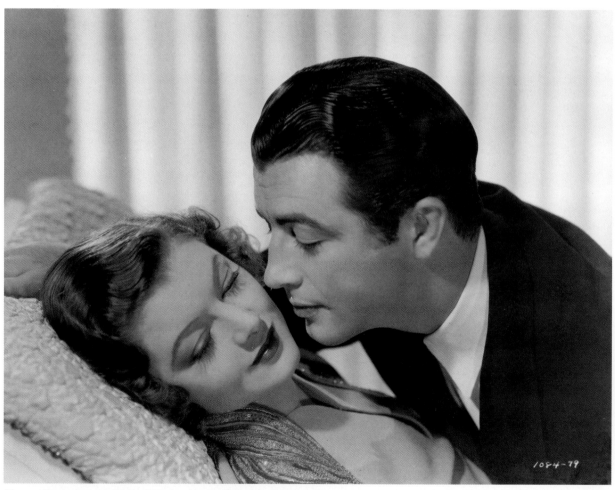

Above: Myrna Loy and Robert Taylor, Laszlo Willinger, from *Lucky Night*, MGM, 1939. Opposite page: Errol Flynn, Scotty Welbourne.

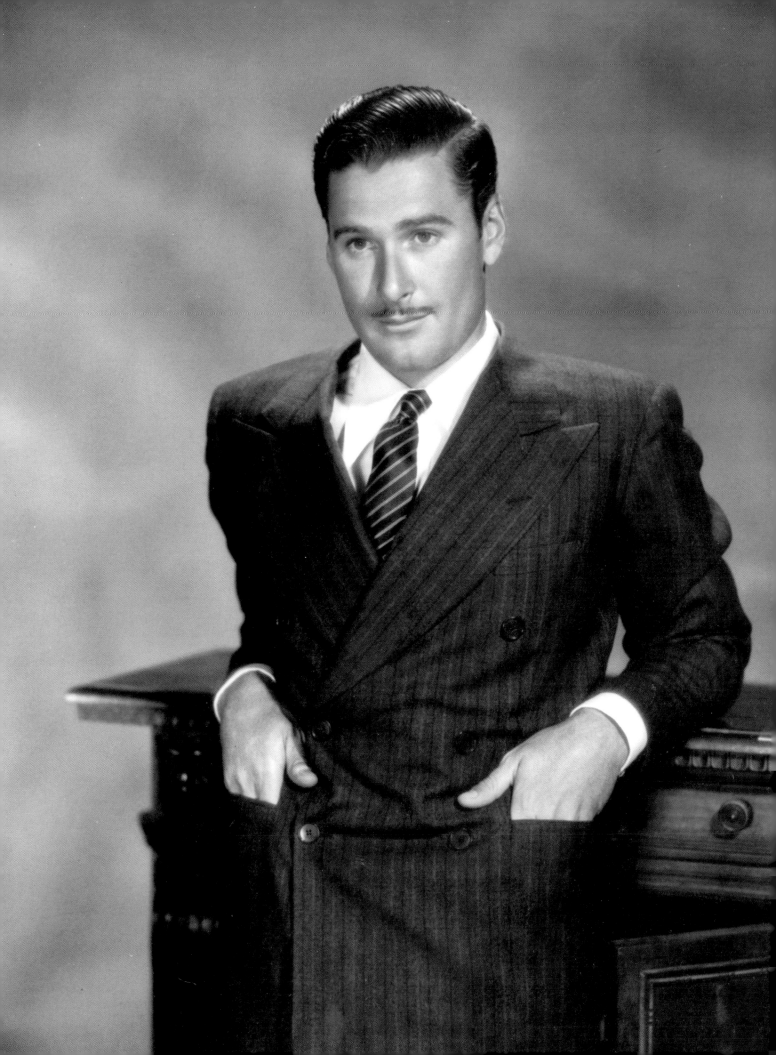

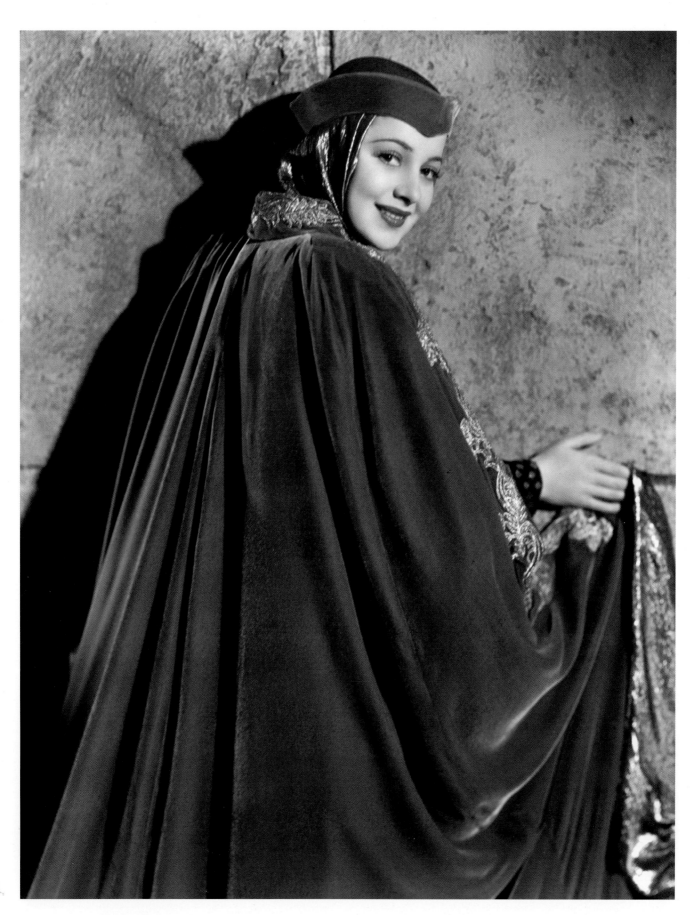

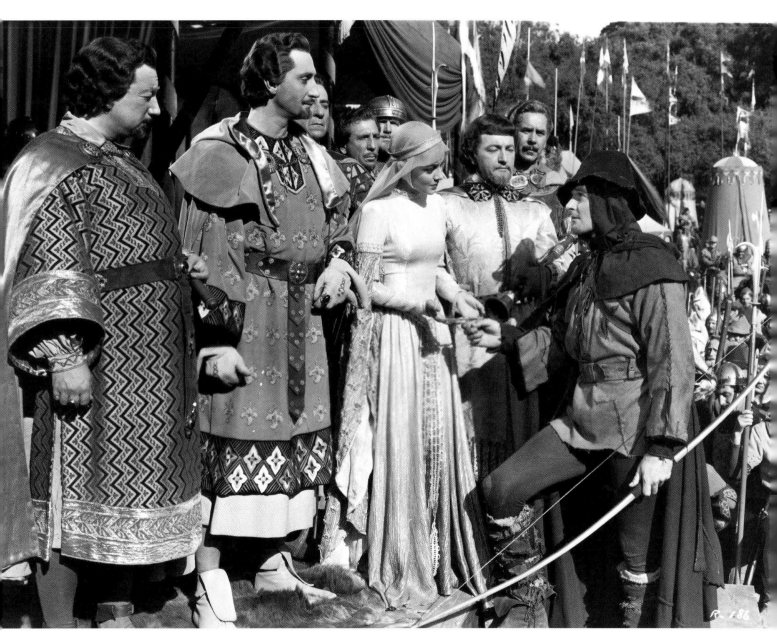

Above: Basil Rathbone, Olivia DeHavilland, Claude Rains, and Errol Flynn from *The Adventures of Robin Hood*, Warner Brothers, 1939. Opposite page: Olivia DeHavilland as Maid Marian, Elmer Fryer, from *The Adventures of Robin Hood*.

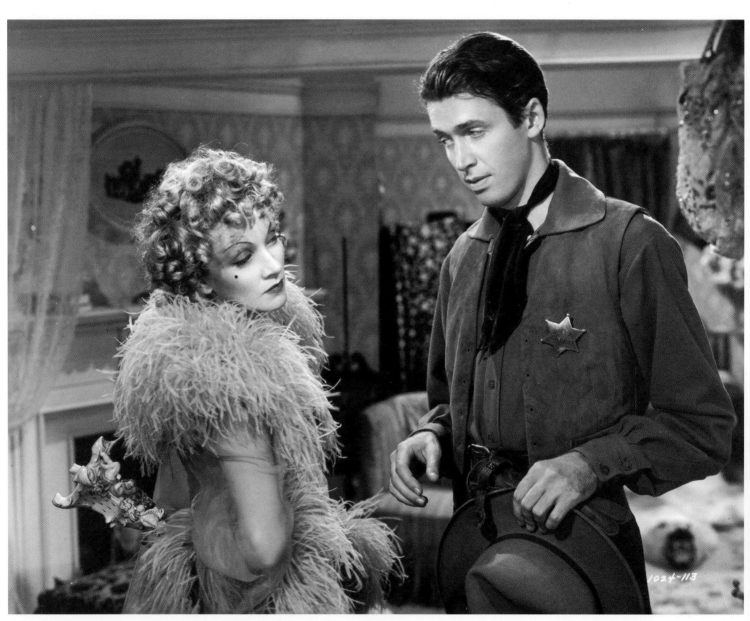

Above: Marlene Dietrich and Jimmy Stewart from *Destry Rides Again*, Universal, 1939. Opposite page left: Joan Crawford and Spencer Tracy, George Hurrell, from *Mannequin*, MGM, 1938. Right: Joan Crawford, Laszlo Willinger.

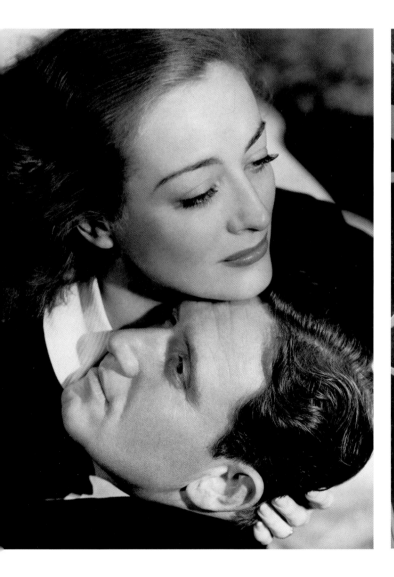

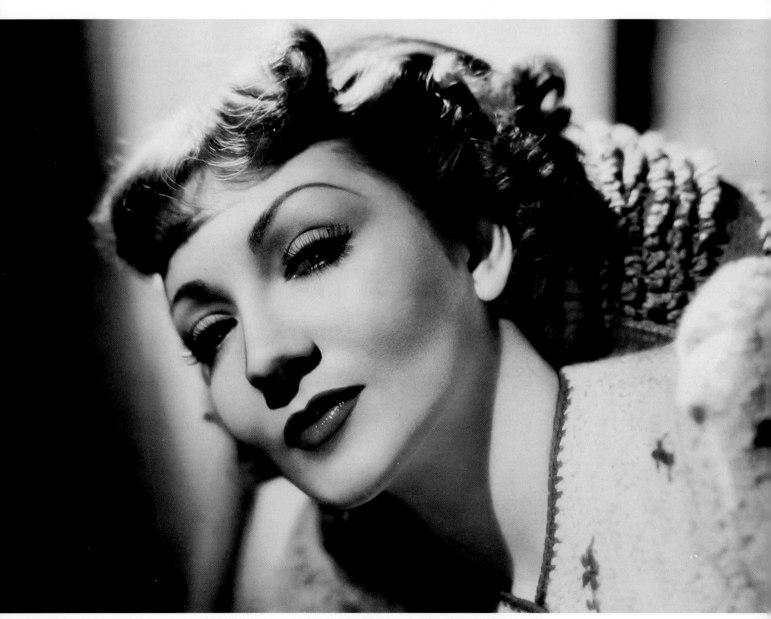

Above: Claudette Colbert, E. R. Richee. Opposite page: Warner Oland and Boris Karloff from *Charlie Chan at the Opera*, 20th Century Fox, 1936.

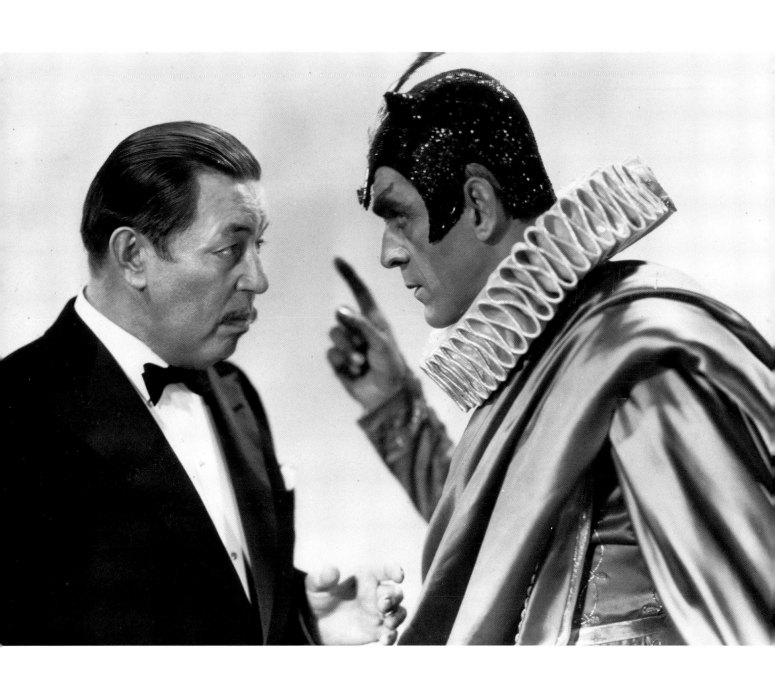

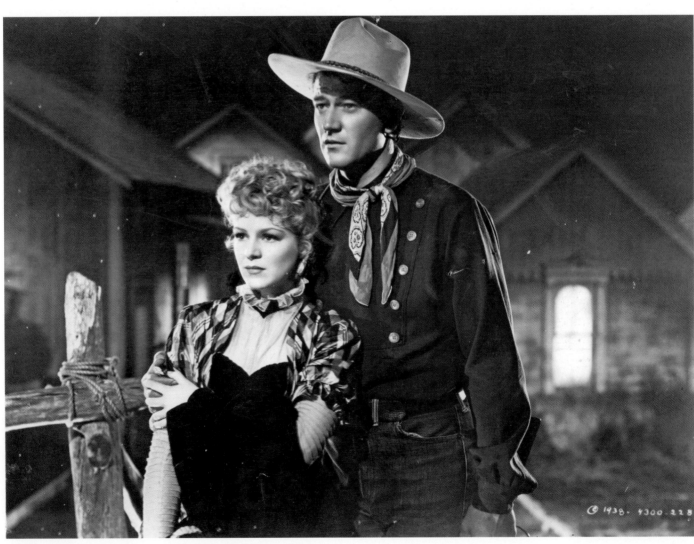

Above: Claire Trevor and John Wayne from *Stagecoach*, United
Artists, 1939. Opposite page: Madeleine Carroll.

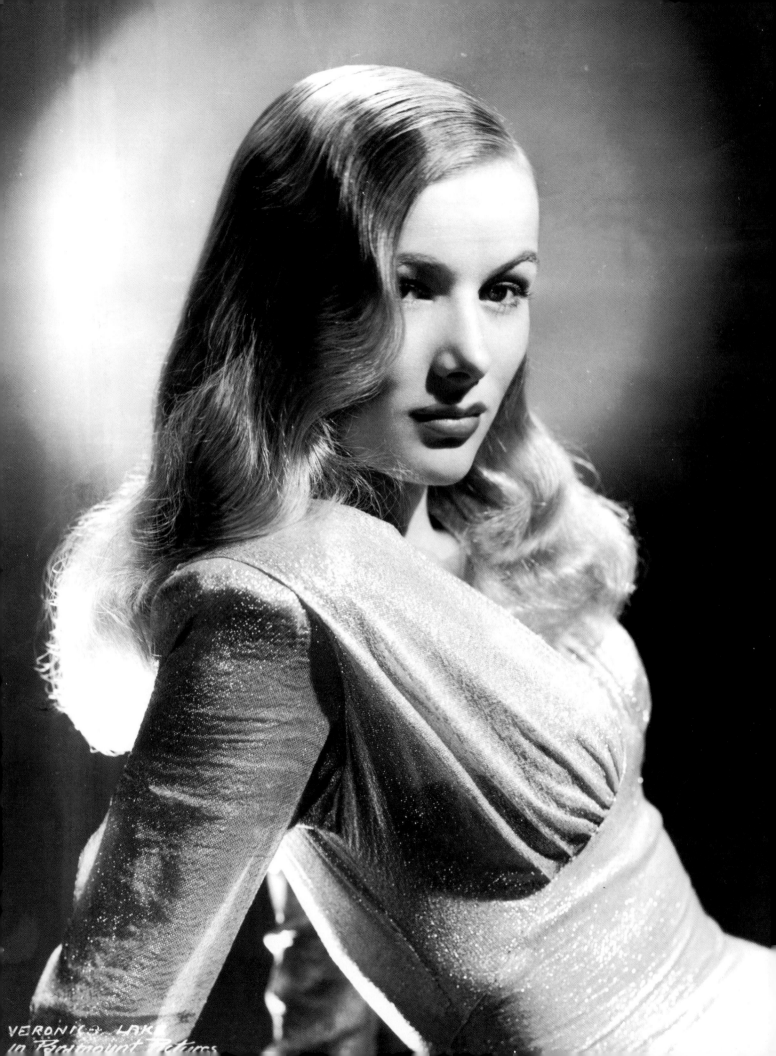

VERONICA LAKE
IN Paramount Pictures

chapter two

1940s: Peek-a-Boo Bang; the Stuff Dreams are Made of; the War; Bogart and Bacall; and Film Noir

The 1930s set the stage for the development of the Hollywood "style" of movie star portraits and scene still photography; the decade to follow witnessed a noticeable change in the attitude of the studios' promotional photography. As the 1940s progressed, out were meditative, self-absorbed, light-bathed fantasy portraits. In were photos that were conscious of the hard new realities of the war, and, its aftermath.

The mood and tone of film stills were, as usual, dictated by the studios, which were reacting to the Second World War and the changes in public taste and sentiment. While individual photographers had some latitude they were required to march in lock-step to the orders of their employers. The studio photographers were reacting to these needs and adapting to them. Clarence Sinclair Bull was still in charge at MGM as was Ernest Bachrach at RKO. E. R. Richee had been replaced at Paramount by A. L. "Whitey" Schafer. Joining

Veronica Lake, George Hurrell. Lake sports a slinky dress, her signature attitude and peek-a-boo bang.

Schafer as his assistant was an up-and-coming photographic artist, Bud Fraker.

George Hurrell reported for duty in 1942 as a private in the United States Army Air Force and never seriously returned to high fashion Hollywood portraiture. The faces of Hollywood's stills photographers were changing, getting older, and seeing the addition of some new blood.

The 1940s saw the rise of Humphrey Bogart, first with a role that started to establish his archetypal anti-hero with *High Sierra* (1941), followed by *The Maltese Falcon* (1941), and culminating with his role in *Casablanca* (1942). Bogart's persona was complemented, on and off the screen by Lauren Bacall, who starred with him in *To Have and Have Not* (1944), *The Big Sleep* (1946), *Dark Passage* (1947), and *Key Largo* (1948). George Hurrell's iconic portrait of Bogie on page 68, taken before he became a big box office star, sometime in 1940, is a sympathetic study of a multi-faceted actor. E. R. Richee's portrait of Lauren Bacall, on the following page, perfectly captures her

disarmingly direct and sexy attitude. Both of these studies are representative of the screen personalities developed for these stars, and also serve as effectively memorable portraiture.

Hollywood sent its biggest stars to war, at least in the movies, and made sure that its fare was fully supportive of the troops and their efforts. Sherlock Holmes was taken from the 19th century and thrust into the 1940s to fight the Nazis. Holmes and Watson made their first updated appearance as 20th Century detectives in Universal's *Voice of Terror* (1942). The still of Basil Rathbone and Nigel Bruce on page 57 catches both actors during shooting of the title sequence for the film, and eloquently sums up their on-screen chemistry.

Cary Grant was yet another star who was putting the finishing touches on his film persona during the 1940s. Grant started out in film in 1932 cast as a handsome fixture and developed into a leading man, who, while always seeming affable, had an undercurrent of danger about him. The still on page 75, shows a confident actor who would shortly star in *Notorious* (1946), which would further cement his position as a major player in films. This portrait was shot by Al St. Hilaire for Columbia. St. Hilaire had been Hurrell's assistant at MGM and moved to Columbia in 1943 with the help of his old boss.

The 1940s additionally produced a uniquely American cinematic genre: film noir. The pulp magazines of the 1920s and 1930s had given authors the like of Dashiell Hammett and Raymond Chandler an opportunity to have their tales serialized in a publication called *Black Mask*. Hammett's *The Maltese Falcon*, *Red Harvest*, and *The Glass Key* all got their first public exposure through this "pulp wood" magazine. Chandler's hard-boiled, multi-layered yarns, which formed the basis for *The Big Sleep* and *Farewell, My Lovely*, also found their way into print the same way. Hollywood was now translating the genre spawned by these novels into film. The term

film noir originates from post-war French film criticism and is attributed to the cineaste Nino Frank. Noir films are distinguished by the alienation of their characters, dark settings and somber photography. The noir world focused on characters who were ordinary, everyday people who were at the end of their rope, and frequently, facing doom. While the 1930s introduced the gangster genre, noir differs because frequently its characters' destinies are precipitated by fate, coincidence and bad luck. Not very cheery stuff.

One of many actresses associated with film noir, whose portrait graces the first page of this chapter, was Veronica Lake. Lake, who was an excellent comedienne, first got the public's eye in *I Wanted Wings* (1941) and went on to star in director Preston Sturges' *Sullivan's Travels* (1941). Following these films came three noir classics which forever defined the perception of Lake: *This Gun For Hire* (1942), *The Glass Key* (1942), and *The Blue Dahlia* (1946) – all of which featured Alan Ladd as her co-star. The sultry publicity stills for these movies all helped indelibly etch Lake's sardonic gaze and peek-a-boo bang forever in the public's consciousness. Yet again, the stills produced by Hurrell, Richee, and other hands at Paramount helped define the public's perception of an actress and remain potent images to this day. The pictures on pages 84-85 all clearly attest to this fact.

Ladd, whose laconic style complemented the noir ethos also got his big break in *This Gun for Hire* and went on to distinguish himself in other classic films such as *Shane* (1953). Ladd's screen persona is captured on pages 82, 83, and 85.

The hard-boiled detective, the doomed not-entirely-innocent leading man, the friend in search of his comrade on the run, and the shady everyman seduced by the *femme fatale* were ably personified by many actors: Dana Andrews, with Gene Tierney and Clifton Webb, in *Laura* (1944) on pages 78-79; Edward G. Robinson and Fred MacMurry from *Double Indemnity* (1944)

on pages 80-81; Orson Welles from *The Lady from Shanghai* (1948) on page 93; Bogie and Bacall from *The Big Sleep* (1946) on page 70; Bogart and Lizabeth Scott in a Robert Coburn portrait from *Dead Reckoning* (1947) on page 71; Robert Montgomery as Philip Marlowe from *Lady in the Lake* (1947) on page 88; Robert Mitchum in an Alex Kahle portrait from *The Locket* (1947) on page 87; Burt Lancaster from *Brute Force* (1947) on page 90; and the doomed lovers James Garfield and Lana Turner from *The Postman Always Rings Twice* (1946) on page 91. These images are illustrative of the look and feel of noir and preserve the essence of the films in still photography.

The 1940s were not all gloom and doom though. The films of this era were also populated by Tarzan and Jane (not to mention Cheetah and Boy) seen here in a Clarence Sinclair Bull still on page 77, and the Columbia shorts of the Three Stooges, a representative still of Larry, Moe, and Curly can be found on page 94.

Lest we not forget that the 1940s also saw the realization of director Orson Welles' two greatest films, both for RKO, *Citizen Kane* (1941) and *The Magnificent Ambersons* (1942). Welles, a greatly talented but self-destructive enigma, directed these masterpieces back-to-back using ensemble casts of actors who gave some of their most noteworthy performances in these efforts. The still of actress Agnes Moorehead from *The Magnificent Ambersons*, on page 54, in her finest performance during a varied and productive career, is compelling and disturbing at the same time, and, most importantly, mirrors the tragic mood of the film.

Filmgoers of the 1940s were treated to musicals, tearjerkers, historical dramas, and drawn to the theaters by the great and not-so-great actors and actresses of the era. Hedy Lamarr, probably one of the most photogenic stars of the decade had few roles that distinguished her as an actress. A. L. "Whitey" Schafer's portrait of her on page 96, as well as two other photos on page 97 and scene stills by hands unknown, from *Comrade X* (1940) teaming her with Clark Gable, on pages 61-63, are prime examples of her allure.

The studios also presented movies to pull at the heartstrings of the audience, a good example of which would be the melodrama *Waterloo Bridge* (1940), starring Vivian Leigh and Robert Taylor. Page 66 presents a Laszlo Willinger portrait of the pair that attests to the photographer's skill in creating such studies.

Film photography historians have long maintained that the great age of Hollywood glamour photography effectively ended with the conclusion of the 1940s. It is true that the quantity of high concept portrait stills decreased, as such photography was no longer necessary to publicize new films, but as the next chapter will demonstrate, the art of film photography was undergoing a transformation to accommodate changes in taste, the market, and the demands of the studios, but it was still very much in practice.

Above: a portrait of despair rivaling a photograph from the "real world," Agnes Moorehead, *The Magnificent Ambersons*, RKO, 1942. Opposite page: the antipode of the mood of the preceding portrait, Walter Huston as Mister Scratch from *The Devil and Daniel Webster* (originally titled *All That Money Can Buy*), RKO, 1941.

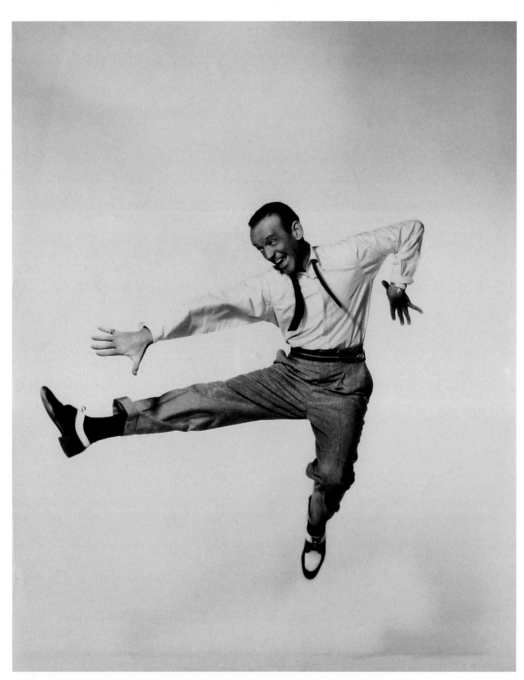

Above: Fred Astaire. Opposite page: Basil Rathbone and Nigel Bruce photographed after the opening credits scene from the first Universal Sherlock Holmes film, *Sherlock Holmes and the Voice of Terror*, Universal, 1942.

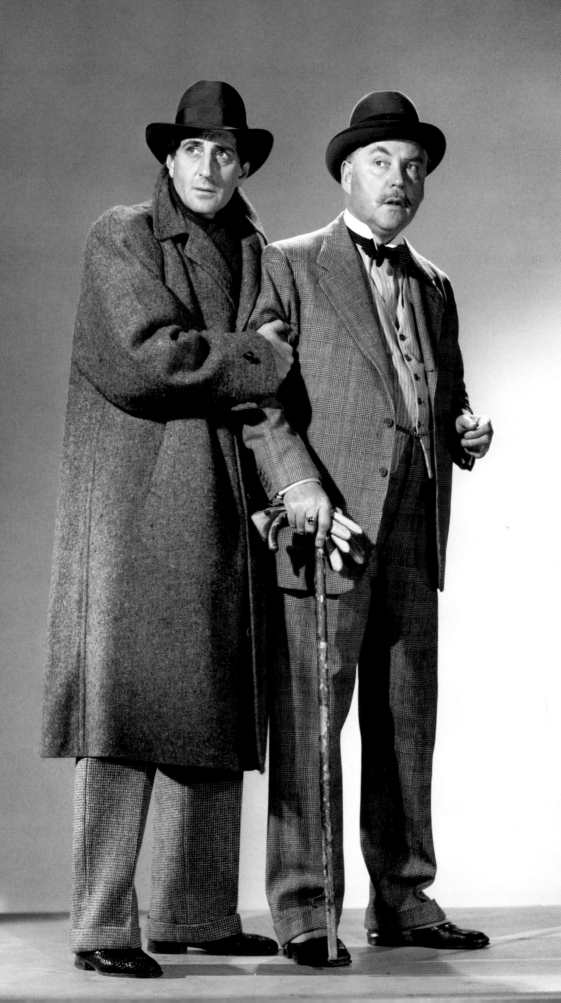

Above: Ann Sheridan, George Hurrell, from *It All Came True,* Warner Brothers, 1940. Opposite page: Ann Sheridan, Madison Lacy, photograph used by the *San Francisco Examiner* for a society column on September 14, 1941, note the pencil "crop lines" in the image.

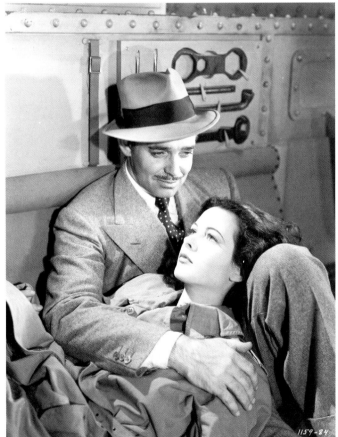

Above and below: Clark Gable and Hedy
Lamarr from *Comrade X*, MGM, 1940.
Opposite page: Jennifer Jones from
Love Letters, Paramount, 1945.

Overleaf: Clark Gable, Eve Ardon, and
Hedy Lamarr from *Comrade X*.

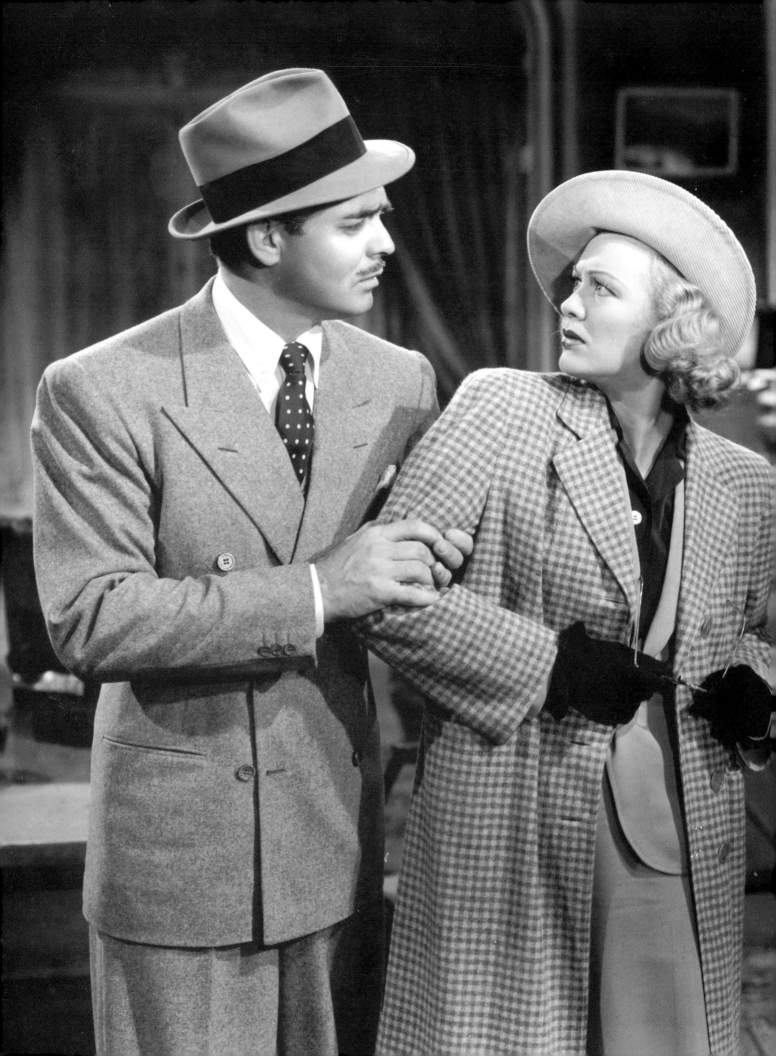

1159-74

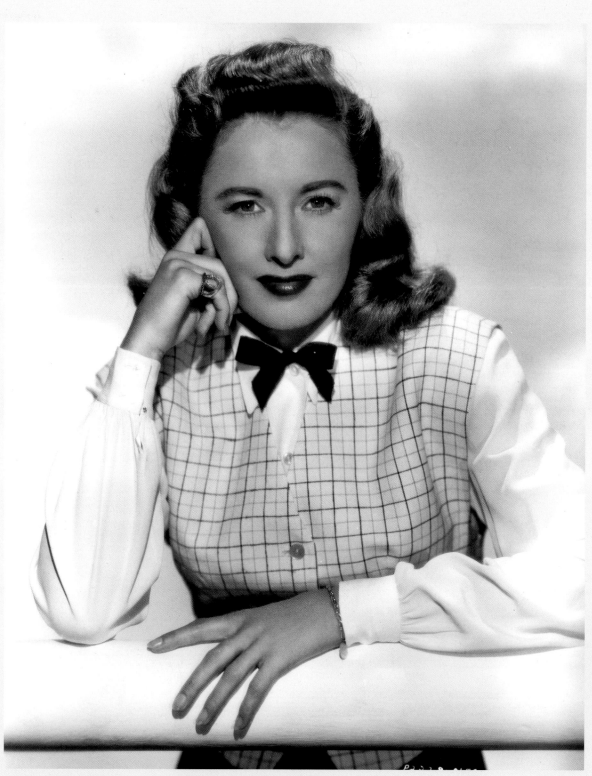

Above: Barbara Stanwyck, A. L. "Whitey" Schafer, 1946. **Opposite page:** Joan Crawford and Conrad Veidt from *A Woman's Face*, MGM, 1941.

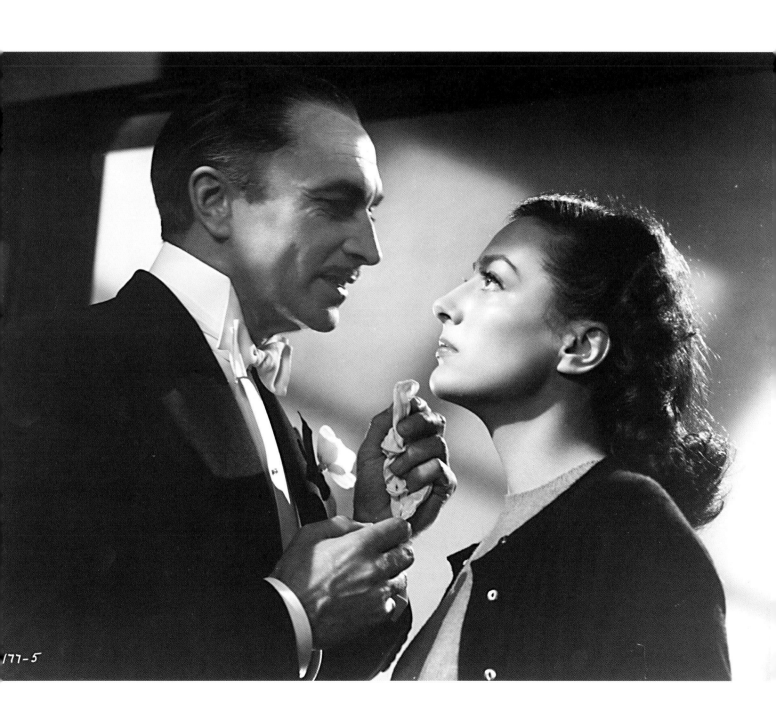

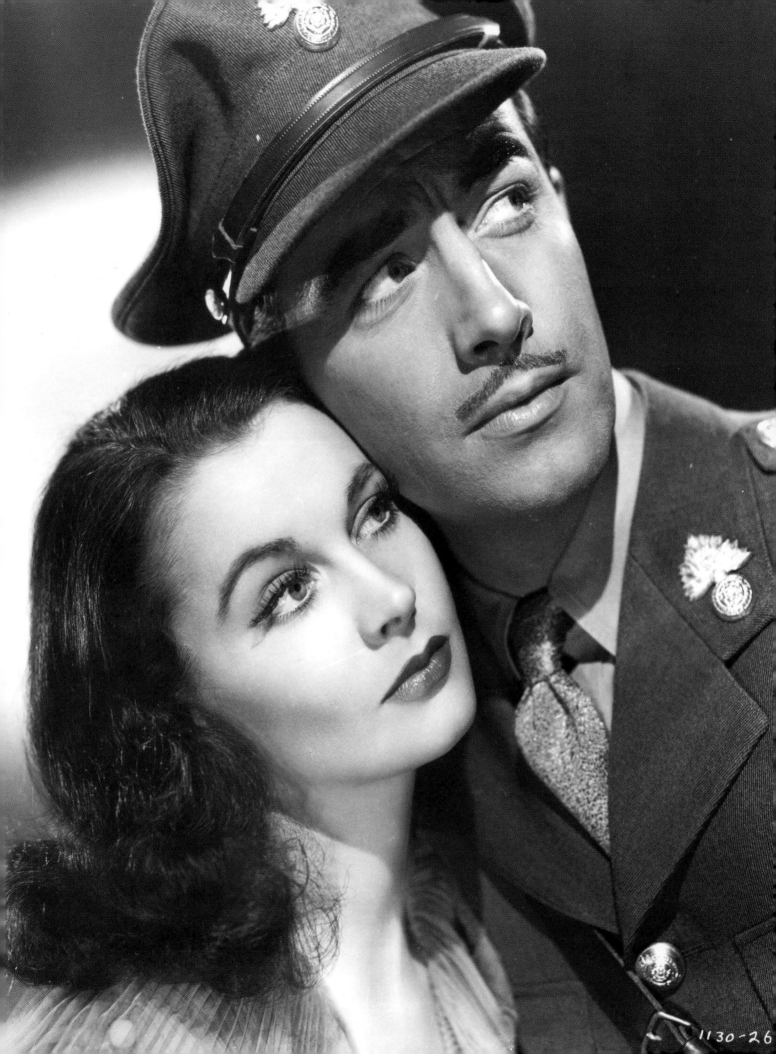

1130-26

Opposite page: Vivian Leigh and Robert Taylor, Laszlo WIllinger, from *Waterloo Bridge*, MGM, 1940. Above: Lola Lane, Alex Kahle, RKO, 1944.

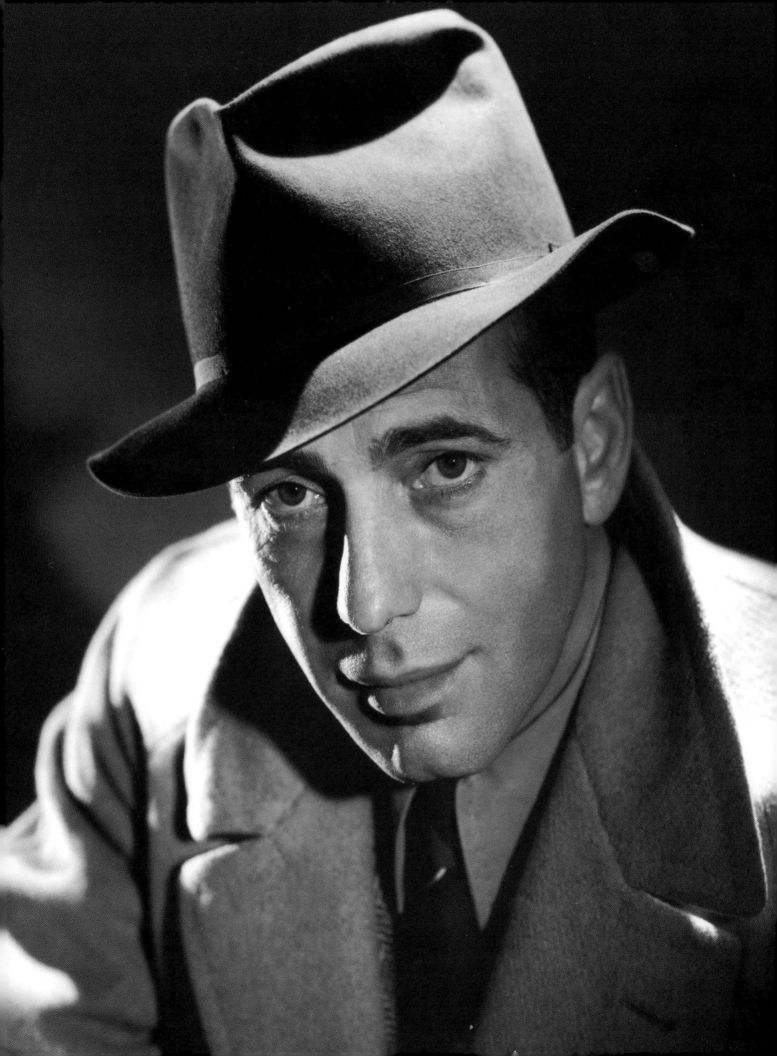

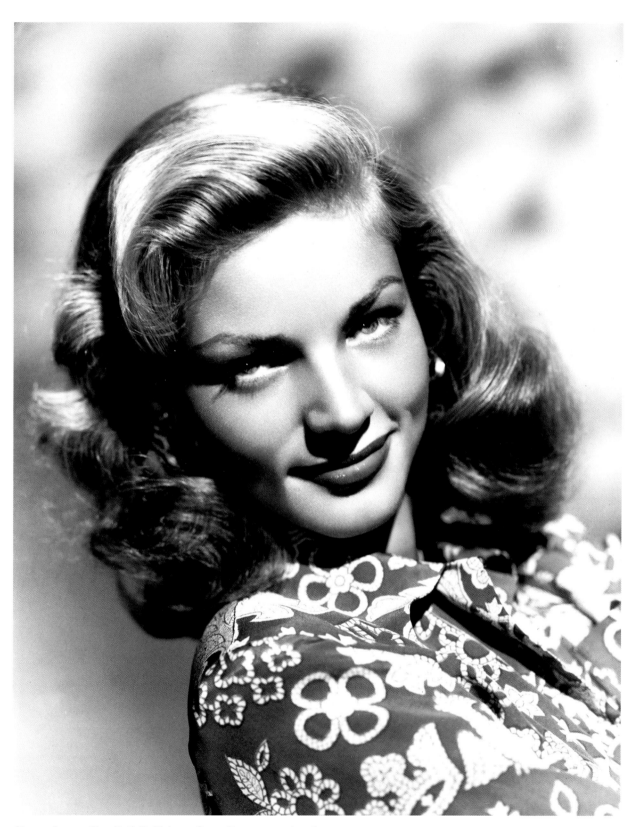

Above: Lauren Bacall, E. R. Richee. Opposite page: an iconic
photograph of Humphrey Bogart, George Hurrell, circa 1940.

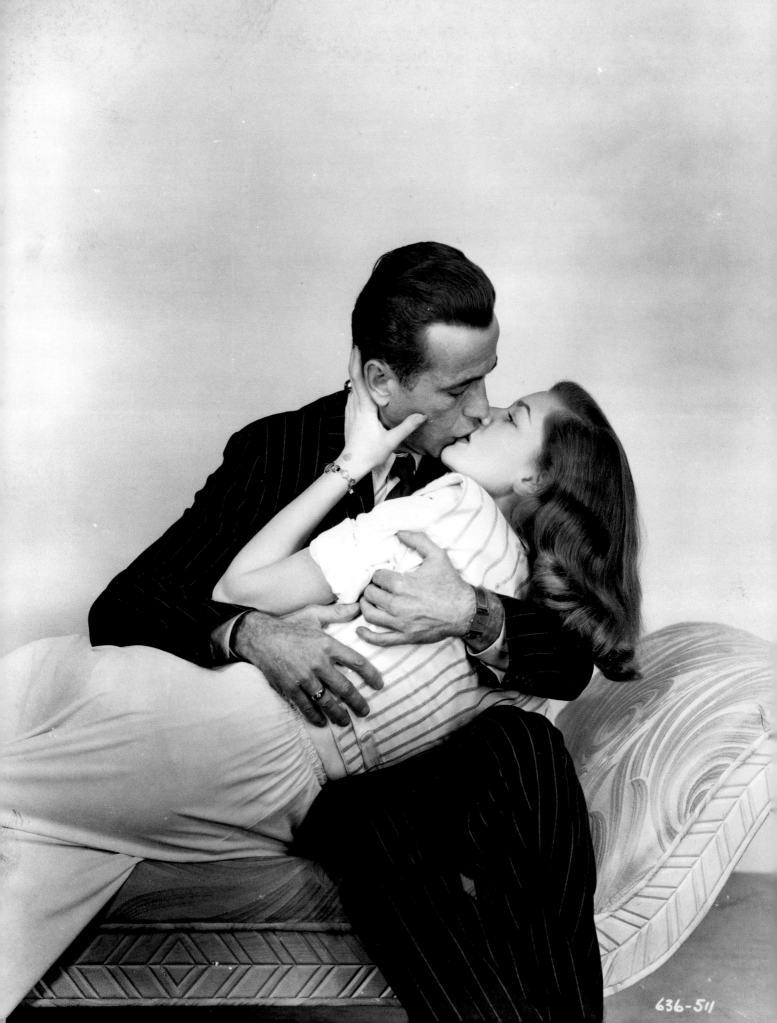

636-511

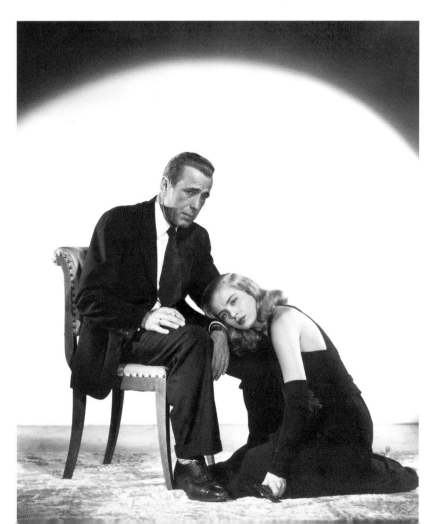

Opposite page: Humphrey Bogart and Lauren Bacall from *The Big Sleep*, Warner Brothers, 1946. Top: Ida Lupino and Humphrey Bogart, Bert SIx, from *High Sierra*, Warner Brothers, 1941. Below: Humphrey Bogart and Lizabeth Scott, Robert Coburn, from *Dead Reckoning*, Columbia, 1947.

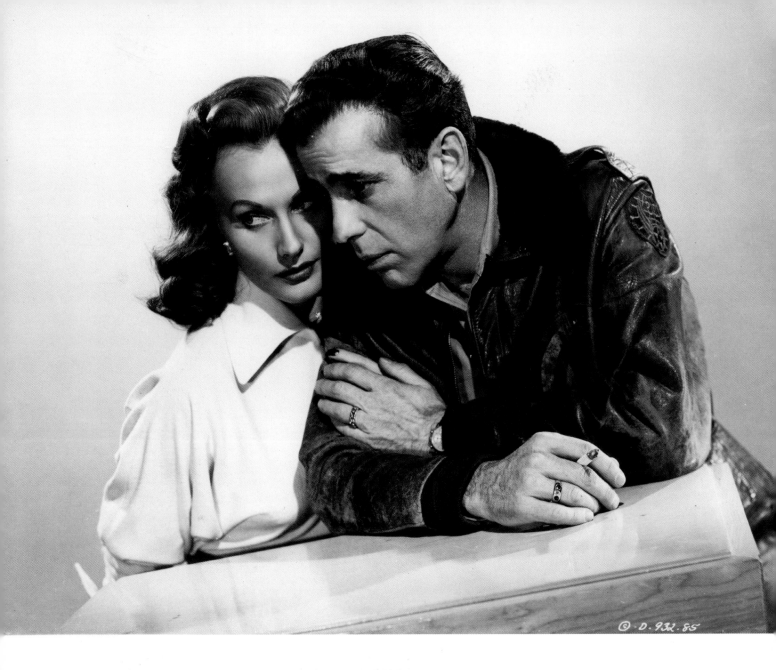

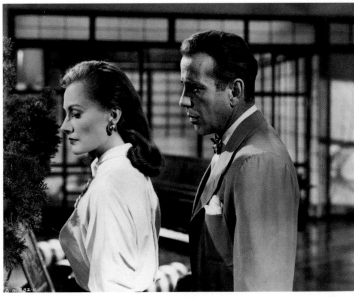

Above and left: Humphrey Bogart and Florence Marly from *Tokyo Joe*, Warner Brothers, 1949. Opposite page: Ava Gardner, Ray Jones, from *The Killers*, Universal, 1946.

Above: Carole Lombard, Robert Coburn, from her last film appearance in
To Be or Not to Be, United Artists, 1942. Opposite page: Cary Grant, Al
St. Hilaire, from *Once Upon a Time*, Columbia, 1944.

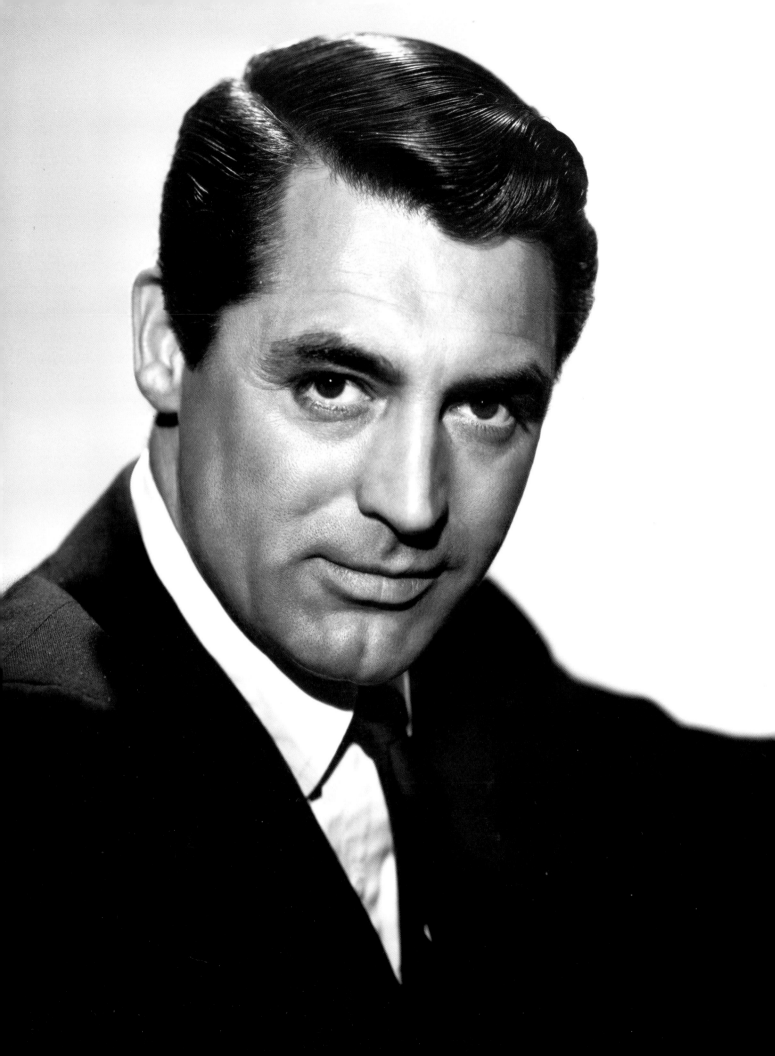

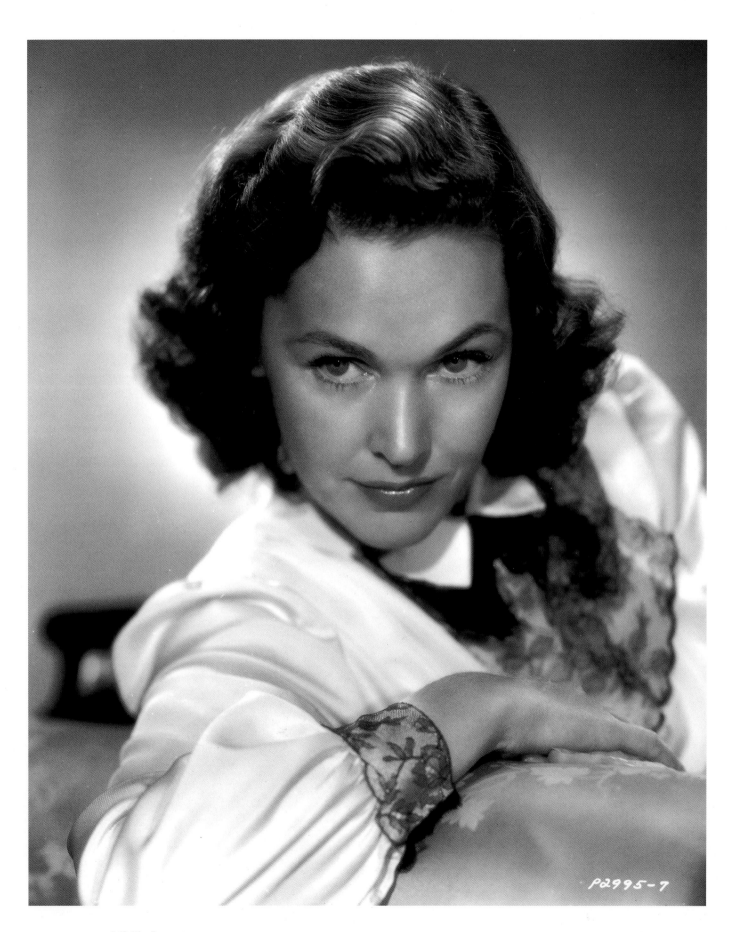

P2995-7

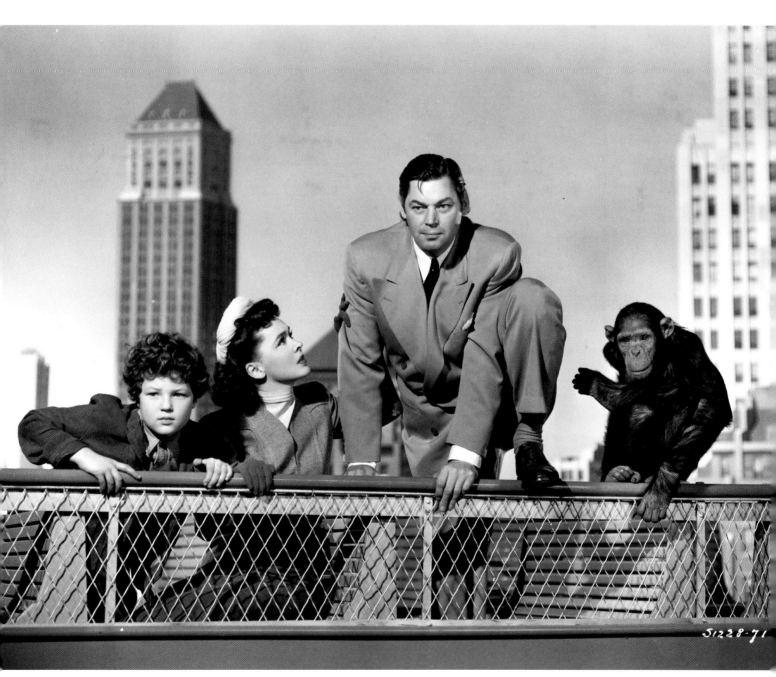

Above: Johnny Weissmuller (Tarzan, this time wearing a suit), Maureen O'Sullivan, Johnny Sheffield, and Cheetah, Clarence Sinclair Bull, from *Tarzan's New York Adventure*, MGM, 1942. Opposite page: Maureen O'Sullivan, 1946.

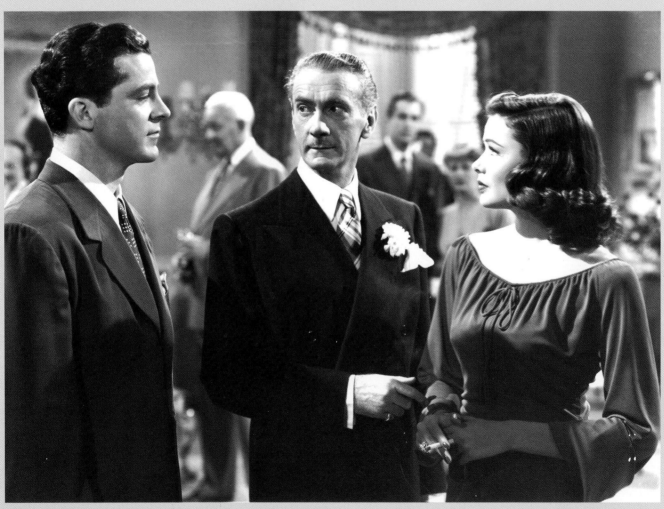

Above: Dana Andrews, Clifton Webb, and Gene Tierney from *Laura*,
20th Century Fox, 1944. Opposite page: Dana Andrews from *Laura*.

Overleaf: Edward G. Robinson and Fred MacMurry from *Double
Indemnity*, Paramount, 1943.

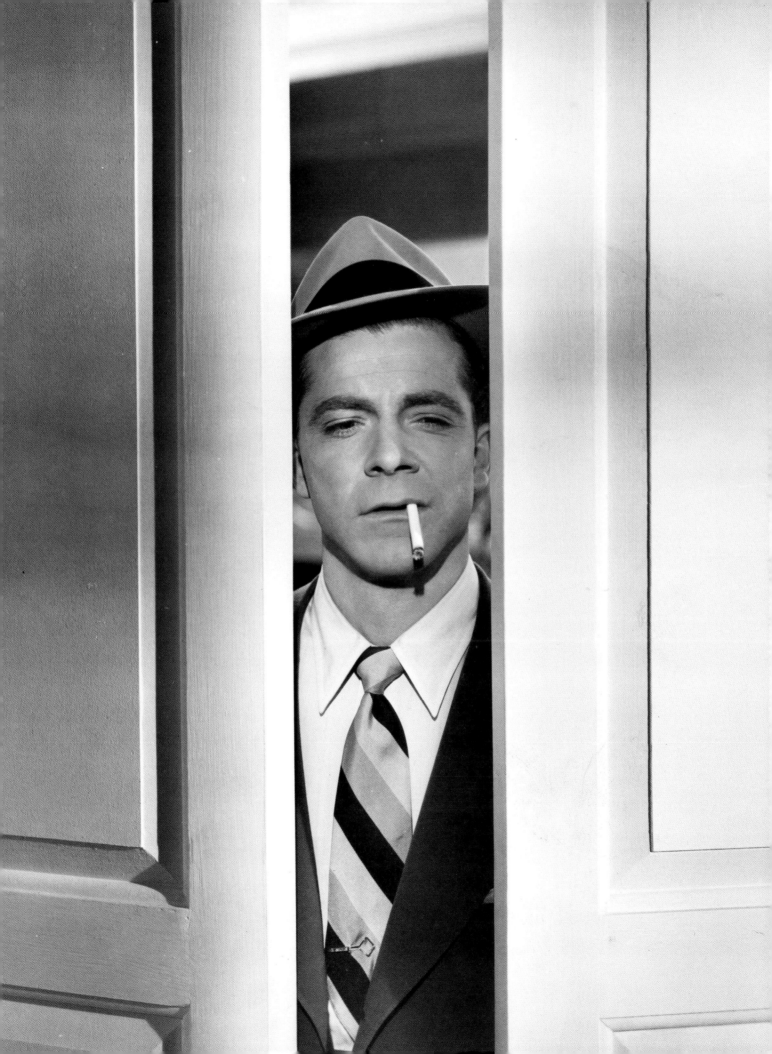

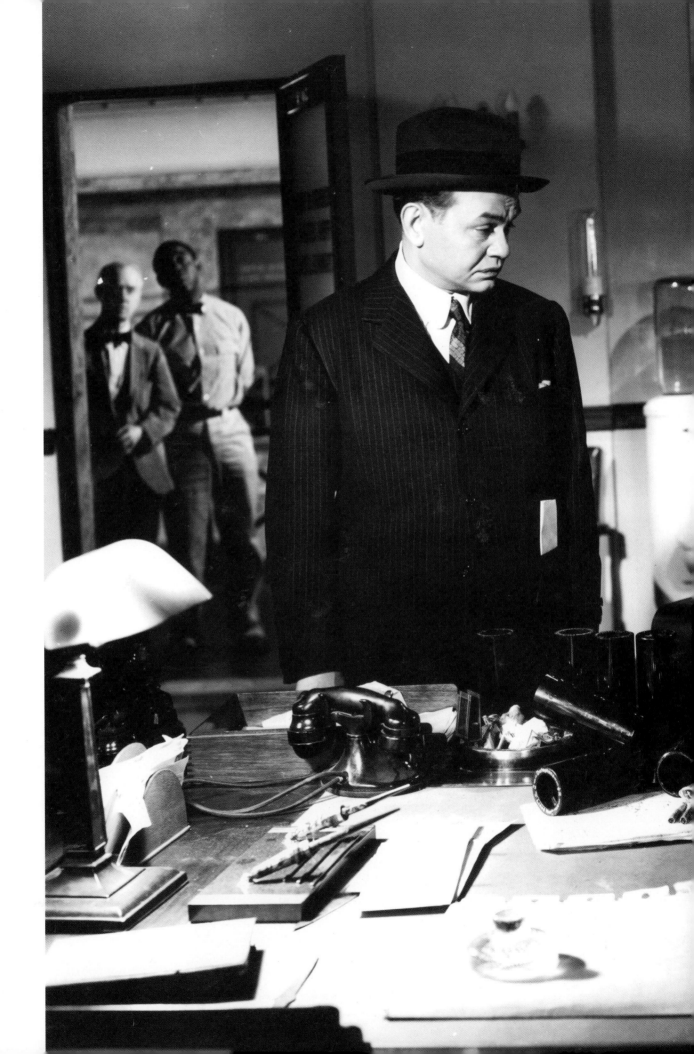

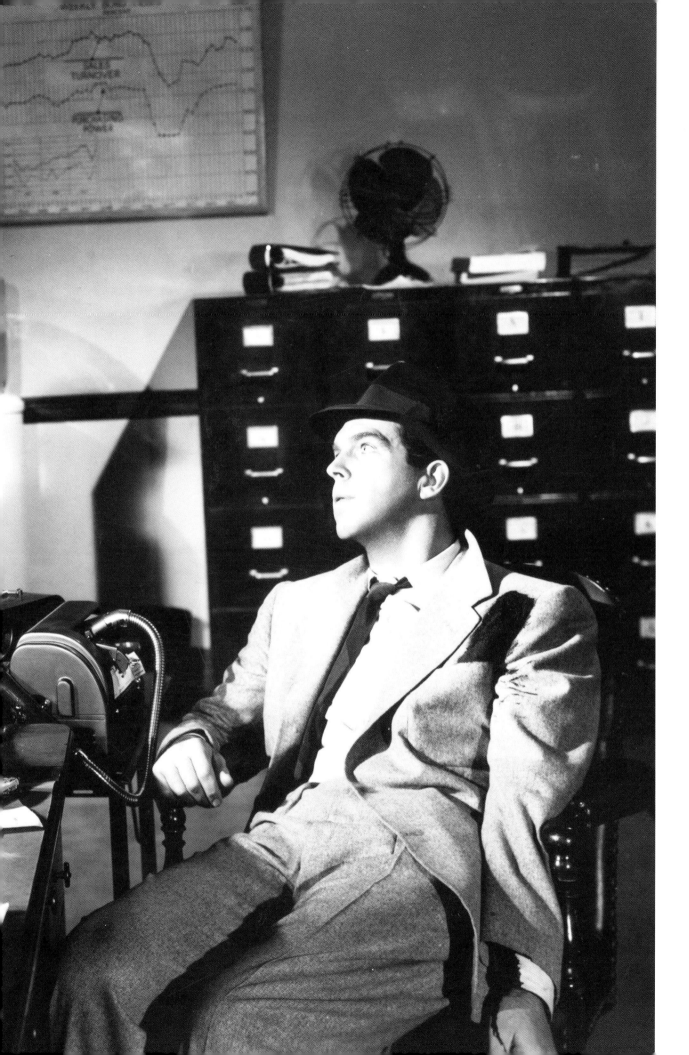

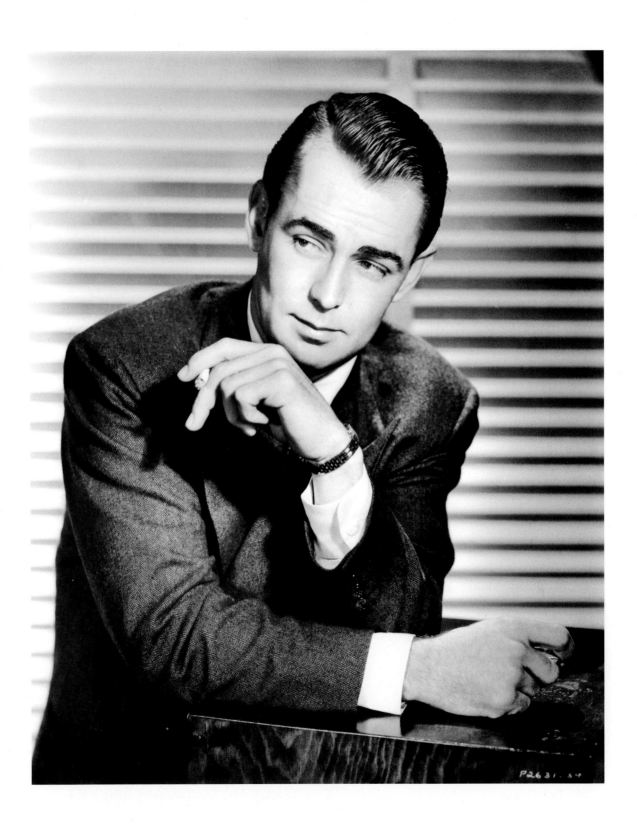

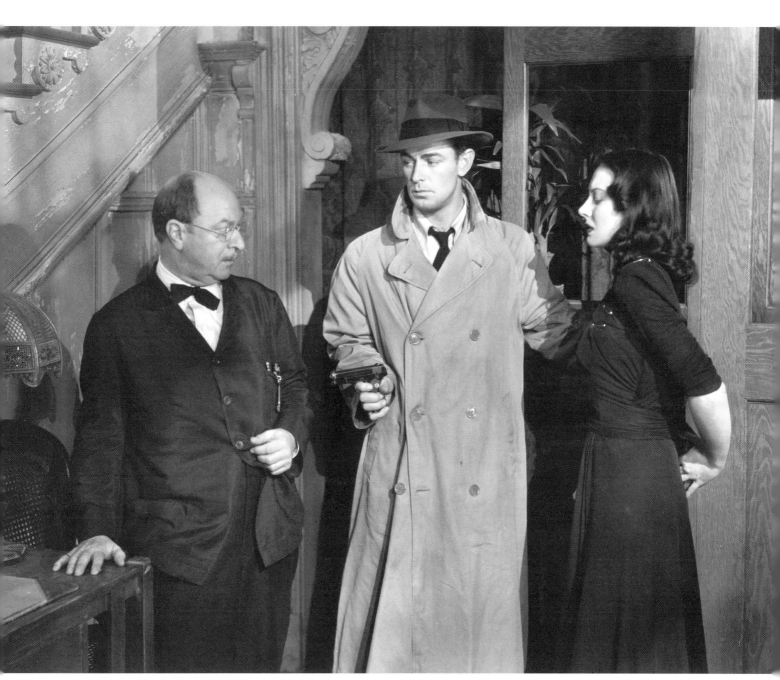

Above: Alan Ladd from *This Gun For Hire*, Paramount, 1942. Opposite page: Alan Ladd, A. L. "Whitey" Schafer, 1942.

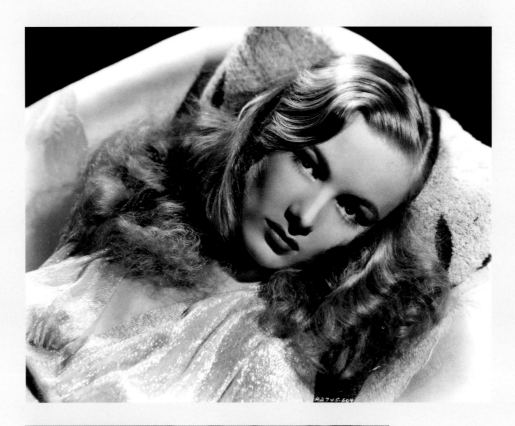

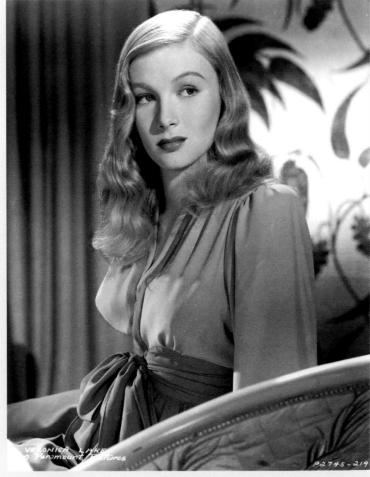

Above: Veronica Lake, George
Hurrell. Bottom: Veronica Lake
from *I Married a Witch,* Paramount,
1942. Opposite page: Alan Ladd
and Veronica Lake from *Saigon,*
Paramount, 1948.

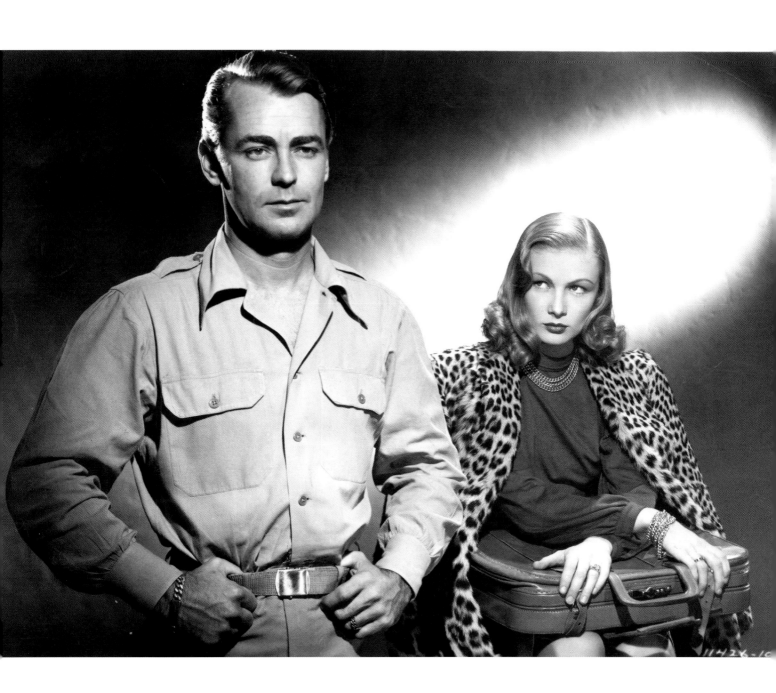

1940s: Peek-a-Boo Bang; the Stuff Dreams are Made of; the War; Bogart and Bacall; and Film Noir

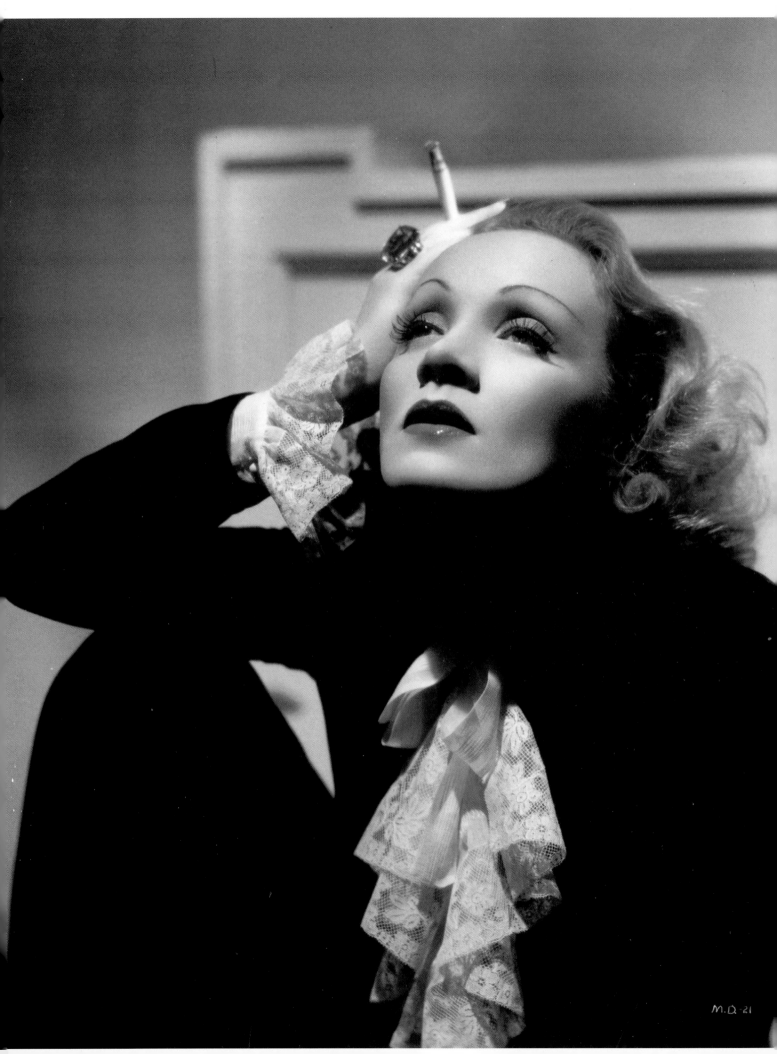

M.D-21

Above: Robert Mitchum, Alex Kahle, from *The Locket*, RKO, 1946. **Opposite page:** Marlene Dietrich.

Above: Robert Montgomery from *Lady in the Lake*, MGM, 1947. Opposite page:
Robert Ryan and Merle Oberon, Ernest Bachrach, *Berlin Express*, RKO, 1948.

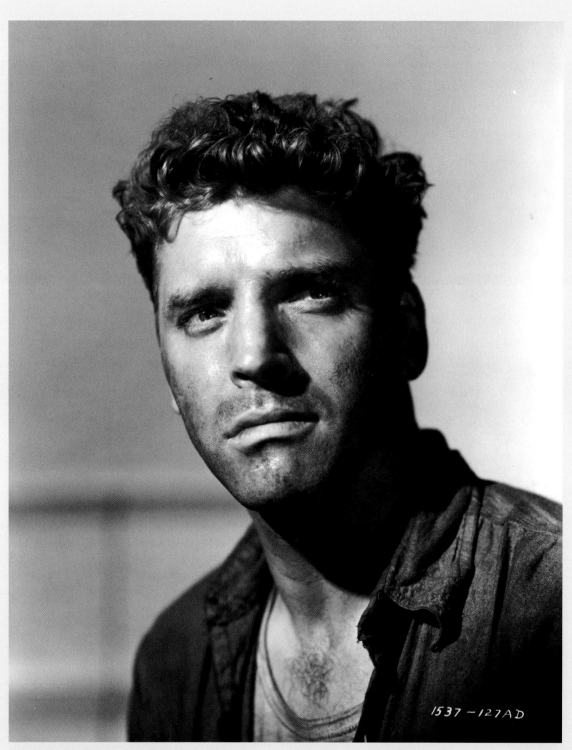

1537 — 127AD

Above: Burt Lancaster from *Brute Force*, Universal, 1947. Opposite page: James Garfield and Lana Turner from the classic film noir, *The Postman Always Rings Twice*, MGM, 1946.

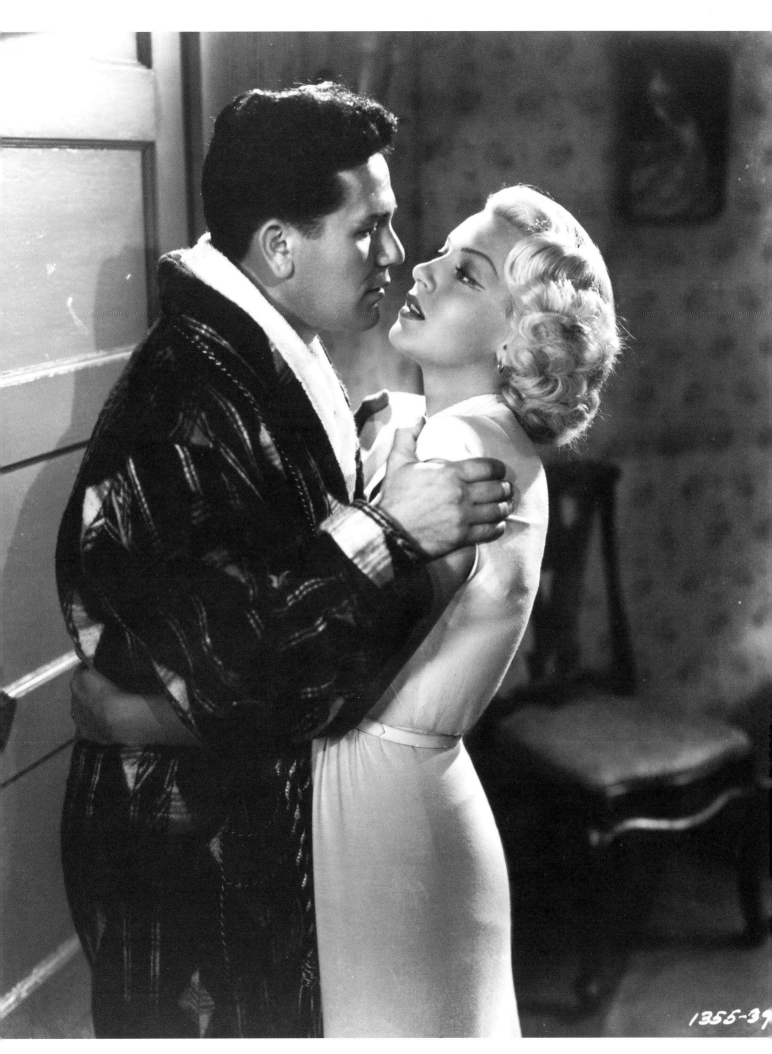

1355-39

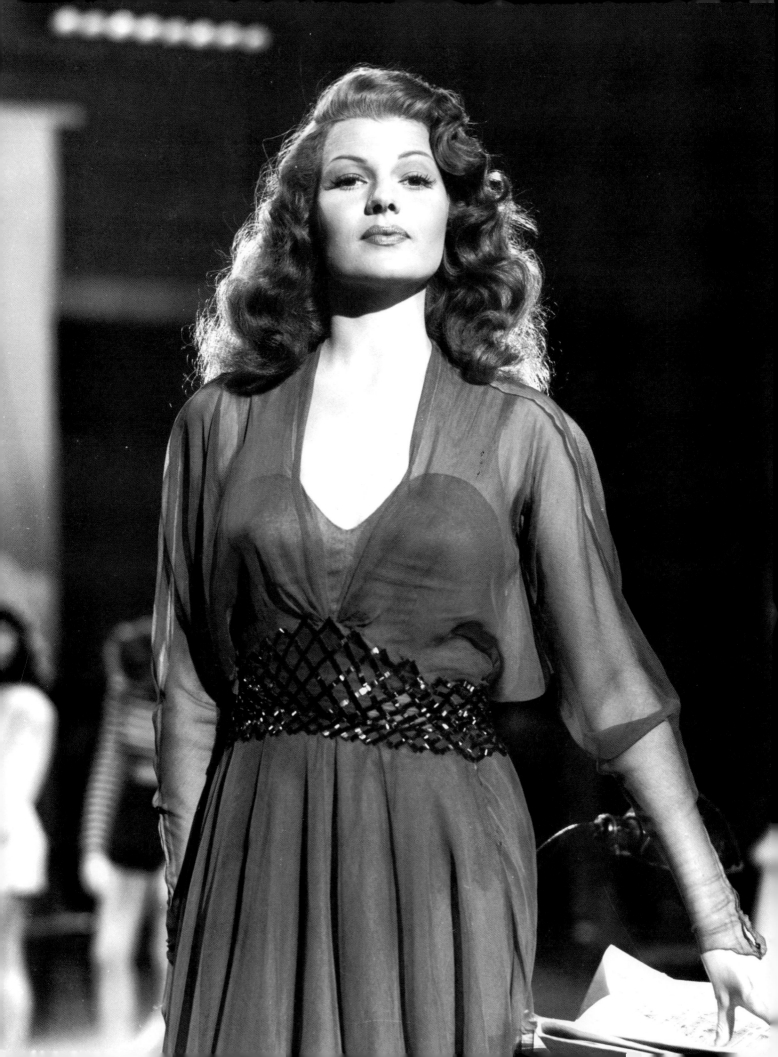

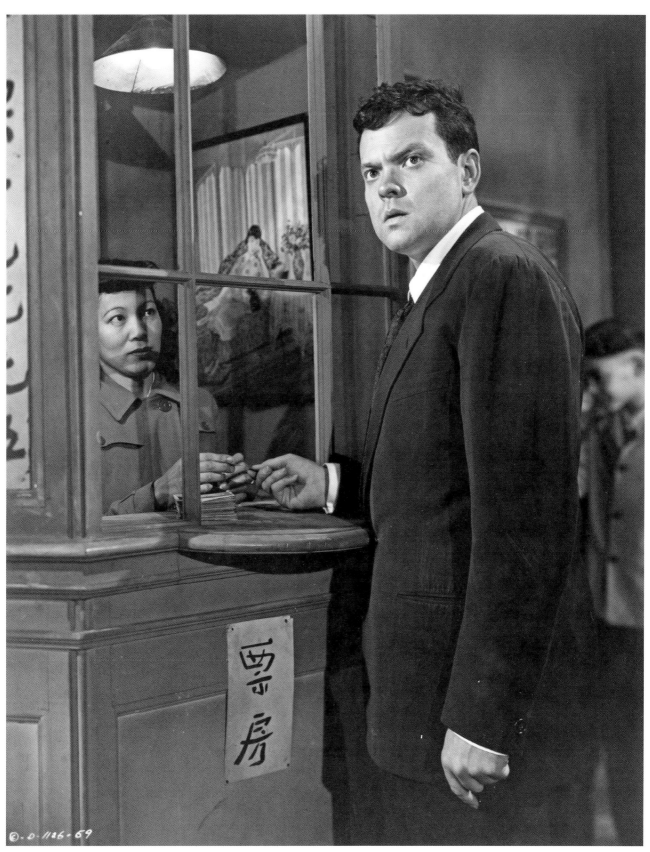

Opposite page: Rita Hayworth, Ned Scott, from *Down to Earth*, Columbia, 1947. Above: the spouse of Rita Hayworth at the time the prior photo was taken, Orson Welles, Edward Cronenweth, from *The Lady from Shanghai*, Columbia, 1947.

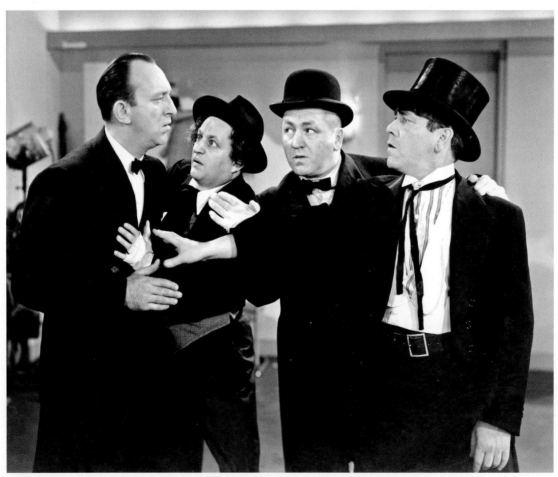

Above: Larry Fine, Curly Howard, and Moe Howard, also known as the Three Stooges.
Opposite page: Deanna Durbin, Ray Jones, from *Christmas Holiday*, Universal, 1944.

1940s: Peek-a-Boo Bang; the Stuff Dreams are Made of; the War; Bogart and Bacall; and Film Noir

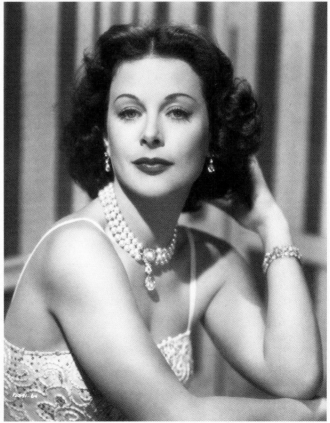

Above and below: Hedy Lamarr. Opposite
page: Hedy Lamarr, A. L. "Whitey" Schafer.

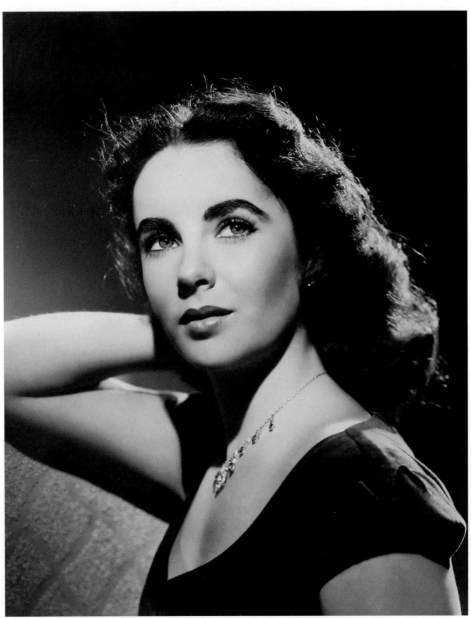

Above: Elizabeth Taylor, Eric Carpenter. Opposite page: Gene Kelly, obviously a trick shot, it nevertheless conveys Kelly's athletically dynamic personality and humor.

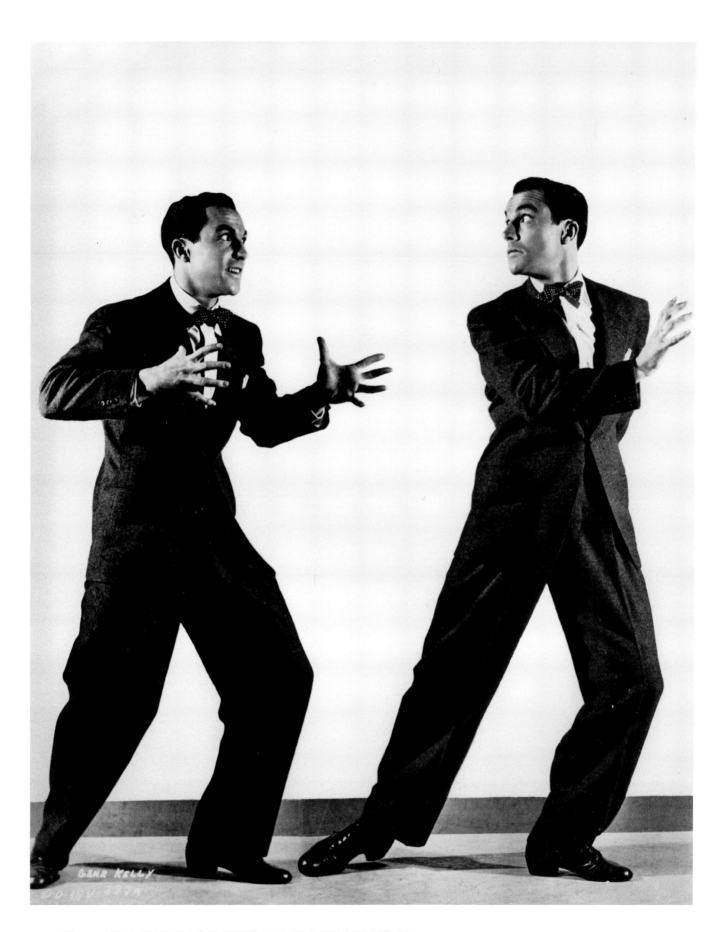

1940s: Peek-a-Boo Bang; the Stuff Dreams are Made of; the War; Bogart and Bacall; and Film Noir

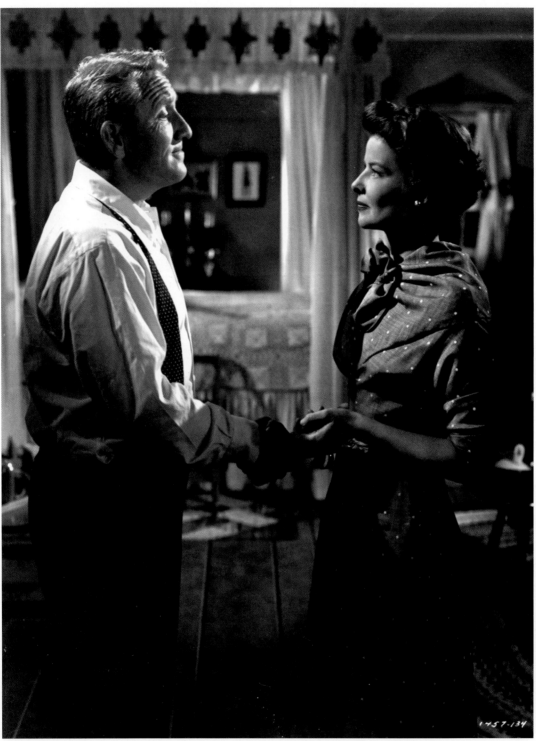

Above: Spencer Tracy and Katherine Hepburn from *Adam's Rib*, MGM, 1949. Of the three famous couples presented in this chapter and the last, Myrna Loy and William Powell, Humphrey Bogart and Lauren Bacall, and Tracy and Hepburn, only the latter two had off-the-screen relationships which added to the sparks seen in their films. **Opposite page:** Janet Leigh.

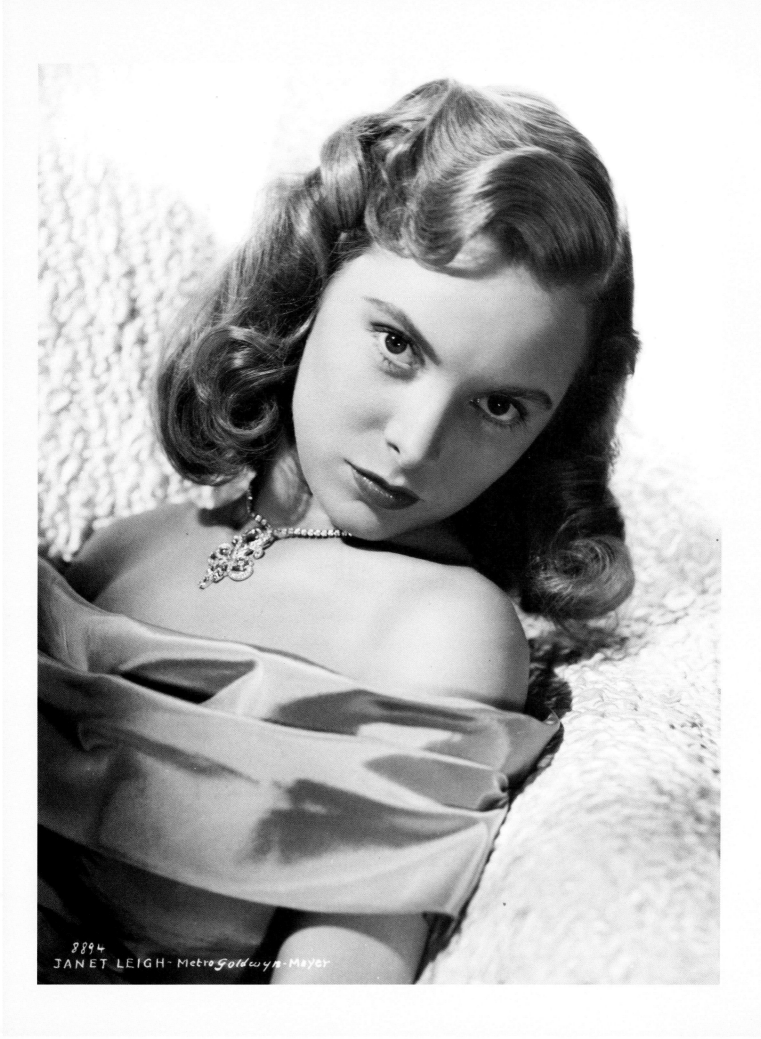

8894
JANET LEIGH - Metro Goldwyn-Mayer

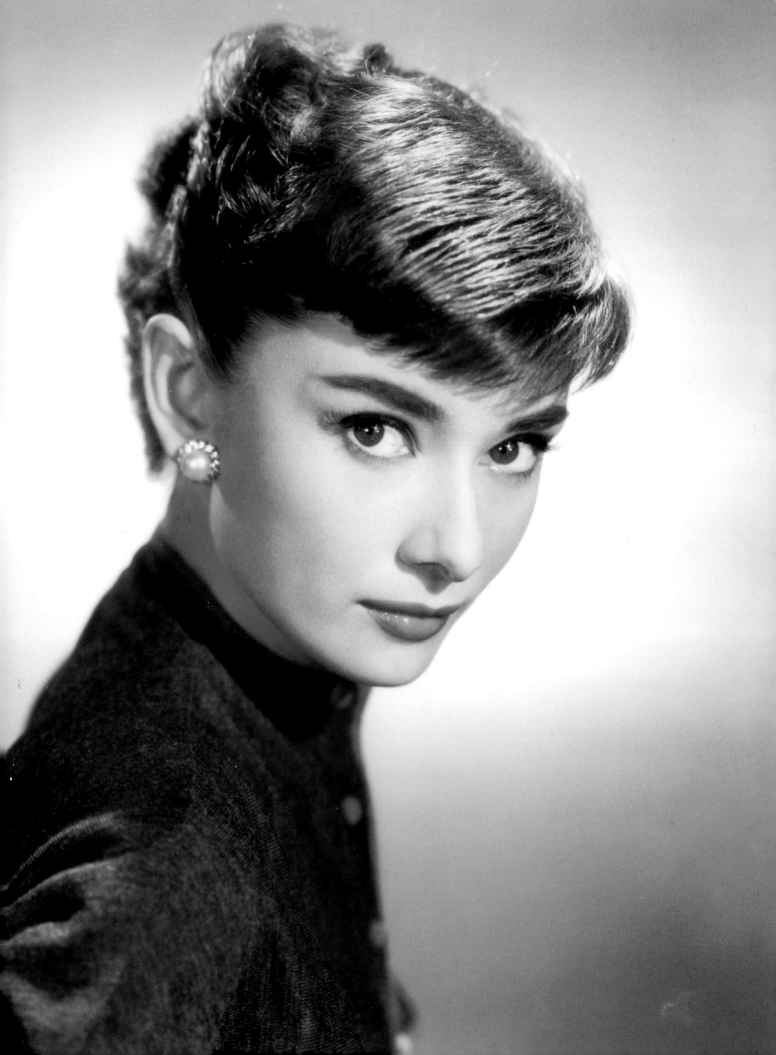

chapter three

1950s: Funny Face and Marilyn; Gort, Sci-fi, and Paranoia; the End of the Studios; and the Times, They Were a Changin'

By the 1950s the film industry was struggling with ways to compete with the advent of television. This was hardly the only problem facing the business though. In 1948 the United States Supreme Court ordered the break-up of the big studios and the theater chains they controlled, further complicating everything for Hollywood. By 1954, the studios could no longer depend on an instant market for their films.

The United States of the 1950s was very different from the era when audiences had paid to see Jimmy Cagney, Clark Gable, Gene Harlow, and Carole Lombard. The end of the Second World War brought with it returning servicemen, the baby boom, and a healthy economy which transformed the American landscape.

The political environment was different as well; with the explosion of the atomic bomb had come a new anxiety that fueled the national paranoia about communism. Dwight Eisenhower was now President; poodle skirts

Audrey Hepburn, Bud Fraker, 1954.

were the rage, TV dinners were served in every home, people ate at the drive-in, Lucy and Ricky were a national obsession, and Marilyn Monroe, James Dean, Rock Hudson, and Doris Day were big stars.

The studios were adapting to these changes and, as always, mirroring the sentiments of the times with their fare. Film noir was still a viable source for material and the decade produced such films as *The Asphalt Jungle* (1950), *D.O.A.* (1950), *In a Lonely Place* (1950), *Pickup on South Street* (1953), *Kiss Me Deadly* (1955), and *The Killing* (1956).

The broad range of movies produced embraced the mood of the decade supplying titles as varied as *The Day the Earth Stood Still* (1951) – stills of Michael Rennie and Gort the robot are on pages 116-117; *A Place in the Sun* (1951) – a photo of Elizabeth Taylor and Montgomery Clift is on pages 122-123; *Invasion of the Body Snatchers* (1956) – with an immediately identifiable image of Kevin McCarthy and Dana Wynter in flight for their lives, is on page 118; *Will Success Spoil Rock*

Hunter? (1957) – a still of Tony Randall and Jane Mansfield is on page 125; and *Imitation of Life* (1959) – a still of Lana Turner and John Gavin is on page 138. The famed Hollywood musicals so popular in the 1940s saw their end with *Funny Face* (1956) starring Audrey Hepburn. Hepburn's infectious charm in this title is obvious in the photograph on page 114, shot by Bud Fraker.

As it had during the preceding two decades, stills photography documented these films and their stars. Many of the veterans who helped establish the art of stills photography for the movies and documented the Golden Age of American cinema were still around, with a little new blood added into their ranks. Clarence Sinclair Bull, Eric Carpenter and Virgil Apger were at MGM; Ernest Bachrach, Alex Kahle, and John Miehle were hard at work at what was left of RKO; Ray Jones and Ed Estabrook were at Universal; Robert Coburn was at Columbia; Bert Six was working at Warner Brothers; Frank Powolny and Gene Kornman were at 20th Century Fox; and A. L. "Whitey" Schafer and Bud Fraker were at Paramount.

The great actors and actresses from the 1930s and 1940s were still working and some of them were box office draws. Clark Gable, Bette Davis, Joan Crawford, Rita Hayworth, Cary Grant, Jimmy Stewart, Gene Tierney, and Lana Turner had all matured and were still getting top billing.

New faces were also being added to the roster of 1950s stars. Highlighted in this chapter are: James Dean with a portrait by Bert Six on page 112; Carroll Baker on page 113; Kim Novak on page 120; Marlon Brando with Jean Simmons and Frank Sinatra from *Guys and Dolls* (1956) on page 121; Marilyn Monroe and Jane Russell from *Gentlemen Prefer Blondes* (1953) on page 124; Charlton Heston on page 126; Grace Kelly with a portrait by Bud Fraker on page 130, Eva Marie Saint with two portraits by Bud Fraker on page 131; and Doris Day with a portrait by Bud Fraker on page 135.

New directors were emerging, bringing a different emphasis and style to the cinema of the 1950s and some old hands were creating some of their best work. John Ford produced the summation of the many themes explored in his oeuvre, and then some, with *The Searchers* (1956). John Huston, again working with Humphrey Bogart, gave moviegoers *The African Queen* (1952). Billy Wilder, as acid-tipped as ever, gave the Hollywood crowd *Sunset Boulevard* (1950) and the American public *Some Like it Hot* (1959).

Alfred Hitchcock, the ole Master of Suspense, gave us two of his finest works, *Vertigo* (1958) and *North by Northwest* (1959). *Vertigo's* motif, unfashionable at the time for mainstream movie fare, was Jimmy Stewart's destructive obsession with co-star Kim Novak, who appeared in a dual role. The photograph on page 133 is a wonderfully concise précis of the film's story, all in one picture. The photo is so indicative of the film as a whole that it was used as one of the lobby cards and in the movie's advertising. This image is frequently used in essays about one of Hitch's most complicated and yet most satisfying works.

North by Northwest, which is a lighter and more appealing film than *Vertigo* is an encyclopedia of Hitchcock themes and works on all levels: as an essay in existential paranoia; an action tale; as a travelogue; and as a merry-go-round of surreal imagery. The still from the film on page 132 depicts an intense Cary Grant perched on Mount Rushmore.

The new generation of directors were serving up a variety of films, some popular, others more complex and harder to digest. Hollywood stills photographers were now having to grapple with films that were now less studio-bound, with actors and actresses who looked more like the movie-going public than stars. This reality is reflected in the scene stills and portraits from the 1950s. Hurrell would have been completely out of his element with such subject material.

The films of Elia Kazan, for instance, presented disturbing subjects that challenged viewers with such movies as *A Streetcar Named Desire* (1951), *On the Waterfront* (1954), *East of Eden* (1955), and *Baby Doll* (1956). The stills on pages 112 and 113 are from the latter two titles. The portrait of James Dean rings with the actor's irreverence and charm, delivered in full by the seasoned Bert Six. The portrait of Carroll Baker on the next page is sensually disturbing and is true to the film it represents.

Director Nicholas Ray also, for a brief period, bloomed as an artist during the 1950s directing such films as *In a Lonely Place* (1950), *Johnny Guitar* (1954), and *Rebel Without a Cause* (1955). Without a doubt one of the most unusual and multi-layered films to come out of the 1950s was *Johnny Guitar*, which partially served as inspiration for Sergio Leone over a decade later when he directed *Once Upon a Time in the West* (1968). The still of Joan Crawford from the film on page 119 is a strange and disturbing portrait of a maturing star.

Despite all these changes Hollywood was still supplying classic portraiture. Bud Fraker's portrait of Audrey Hepburn at the beginning of this chapter is a perfect example of a photograph which literally grabs the viewer, and doesn't let go. Hepburn, the embodiment of sophistication, elegance, and innocent sensuality, was one of the great stars of the 1950s and early 1960s. This portrait is the summation of all the qualities which define Hepburn as an actress and a cultural icon of the era.

Alex Kahle's portrait of Bette Davis on page 106, taken in 1950, gives the actress a less formal, human dimension missing from many of her icy glamour portraits of the 1930s. A. L. "Whitey" Schafer's glowing, enticing, portrait of Gene Tierney on page 108 or Robert Coburn's studies of Glenn Ford with Rita Hayworth and of Rita Hayworth on pages 110-111 are more evidence of the continuation of the traditions established in the 1930s and 1940s with a

contemporary twist. The portrait of the less well-known Tuesday Weld, most likely by Bud Fraker, on page 129, would, during any of the decades covered by this book, be a knock-out.

The last chapter of this volume ends on a note of symbolic nostalgia, with the portraits of Clark Gable and Marilyn Monroe. Both of these stars personified the old Hollywood as well as the end of what is frequently called the "Golden Age." Gable began when sound motion pictures were in their infancy and continued to be an important presence in the film world for the rest of his career. His great love affair with Carole Lombard ended with her tragic death in a plane crash while she was traveling to sell war bonds, and is literally the stuff of American film legend. The King was the consummate professional.

Marilyn Monroe came to symbolize the new sexuality of the 1950s. Marilyn was intelligent, tough, and vulnerable. Her screen persona was only a shadow of who she really was. Both of these stars prospered, in varying degrees, during the 1950s until the end of their lives, right after the period covered in this volume.

The studios nourished stars the like of Gable and Marilyn, just as they set the rules for movie stills photography. As the need changed, the style of the photography changed with it. Film stills photography was an adaptive craft which under the right conditions made the leap into art, just as, on occasion, films transcended being merely commercial creations and aspired to be more.

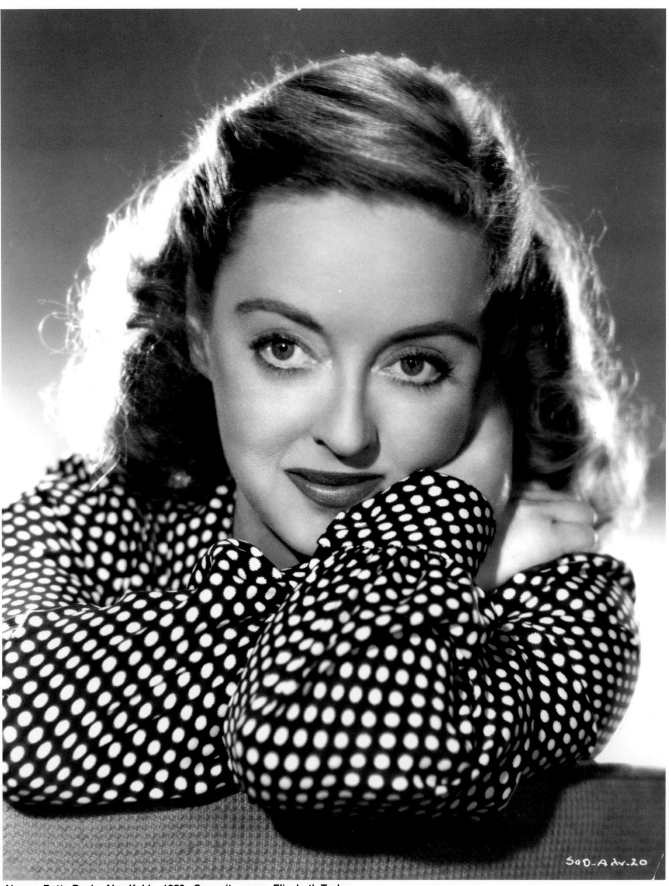

Above: Bette Davis, Alex Kahle, 1950. Opposite page: Elizabeth Taylor
and Rock Hudson, from *Giant*, Warner Brothers, 1956.

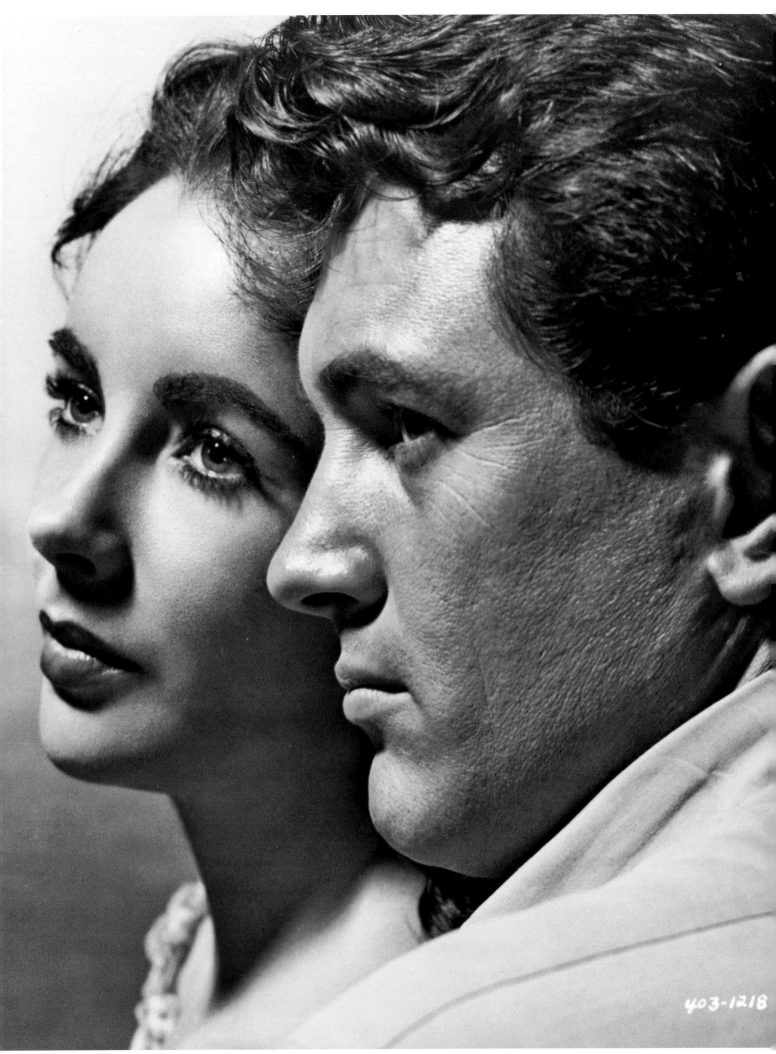

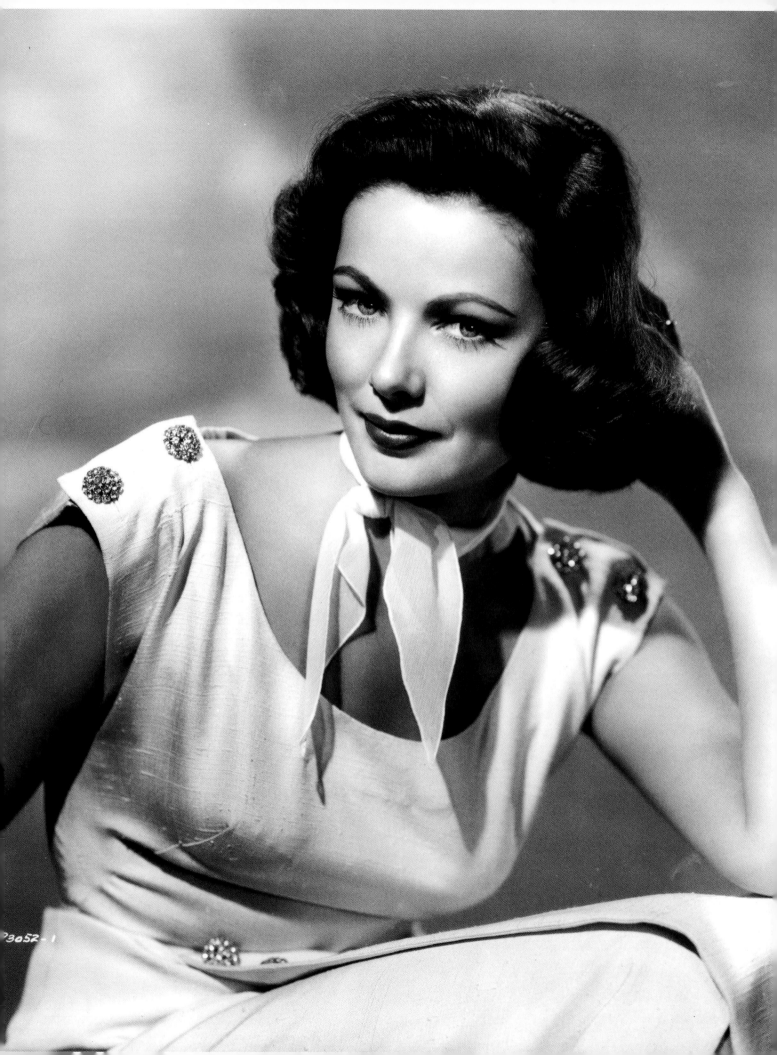

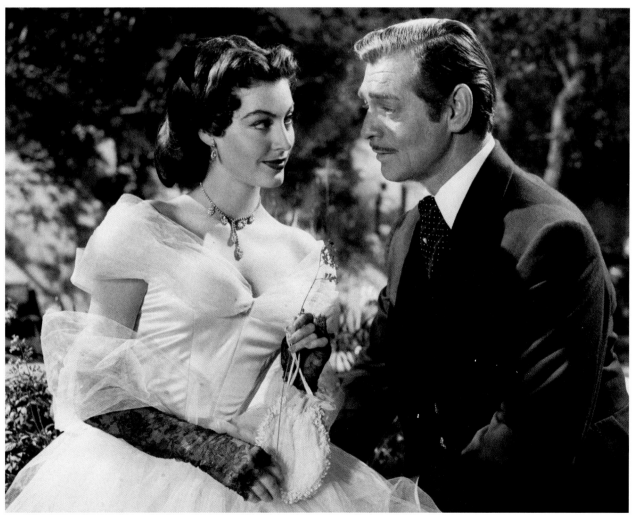

Above: Ava Gardner and Clark Gable from *Lone Star*, MGM, 1952. Opposite page: Gene Tierney, A. L. "Whitey" Schafer.

Above: Rita Hayworth and Glenn Ford, Robert Coburn, from *Affair in Trinidad*, Columbia, 1952.
Opposite page: Rita Hayworth, Robert Coburn, from *Affair in Trinidad,* Columbia, 1952.

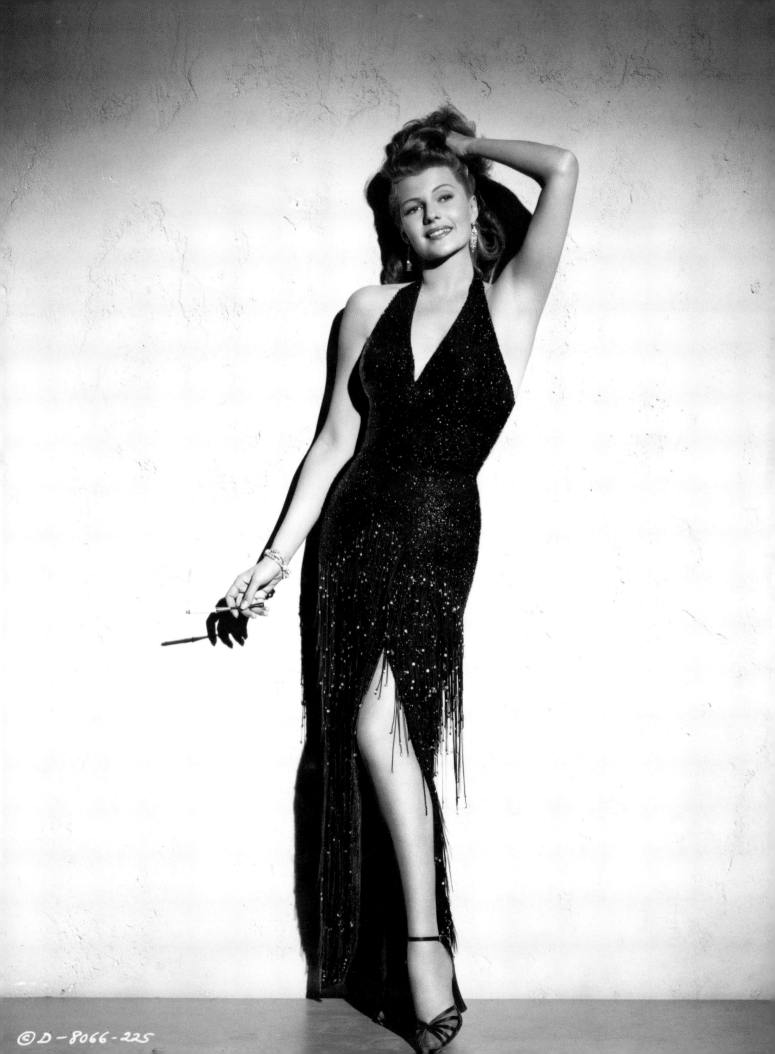

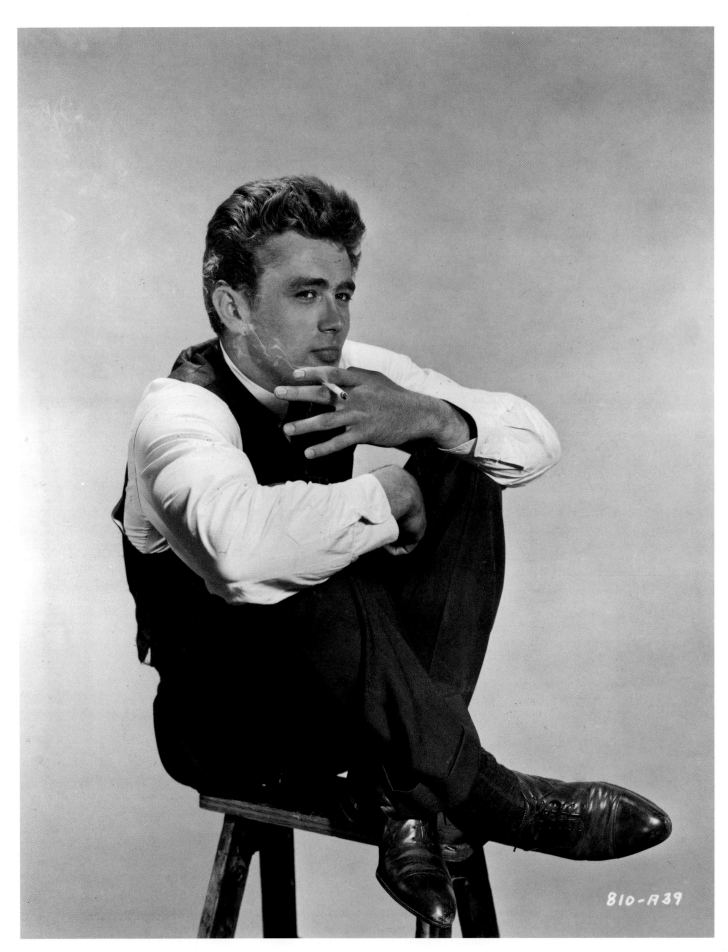

810-A39

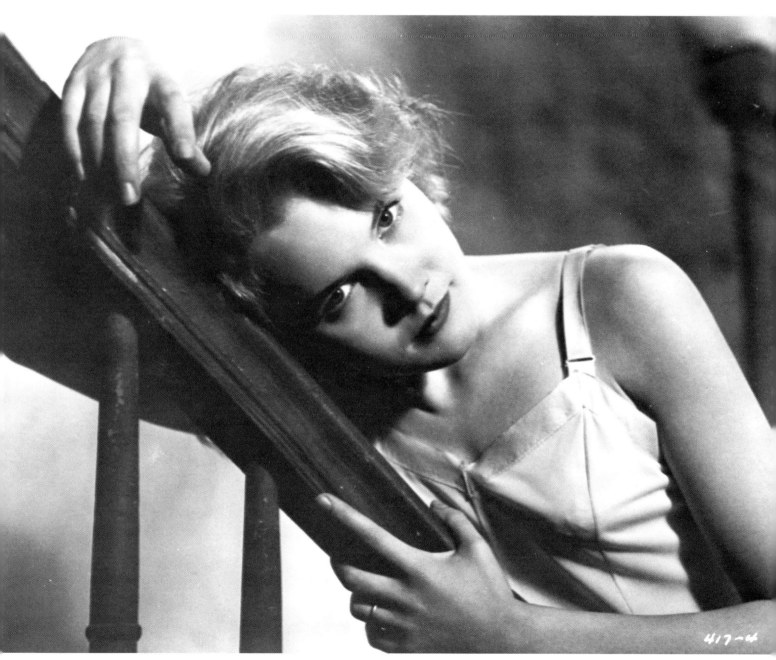

Above: Carroll Baker from *Baby Doll*, Warner Brothers, 1956. Opposite page: James Dean, Bert Six, publicity photo from *East of Eden*, Warner Brothers, 1955. Both films share the same director, Elia Kazan.

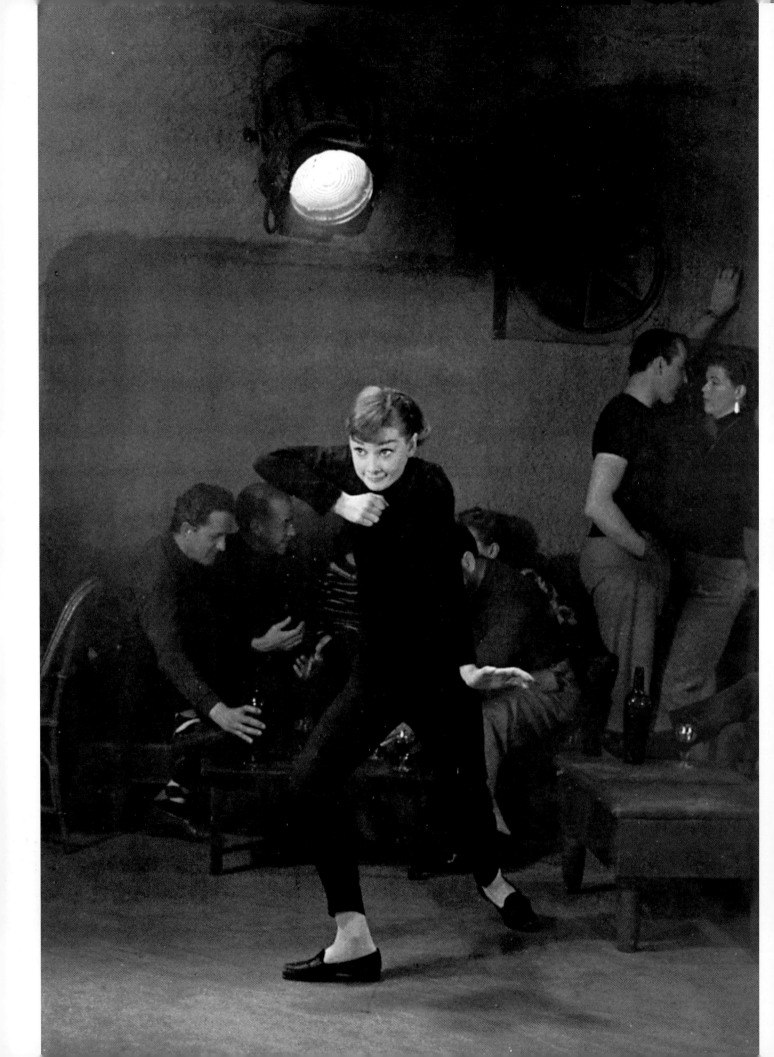

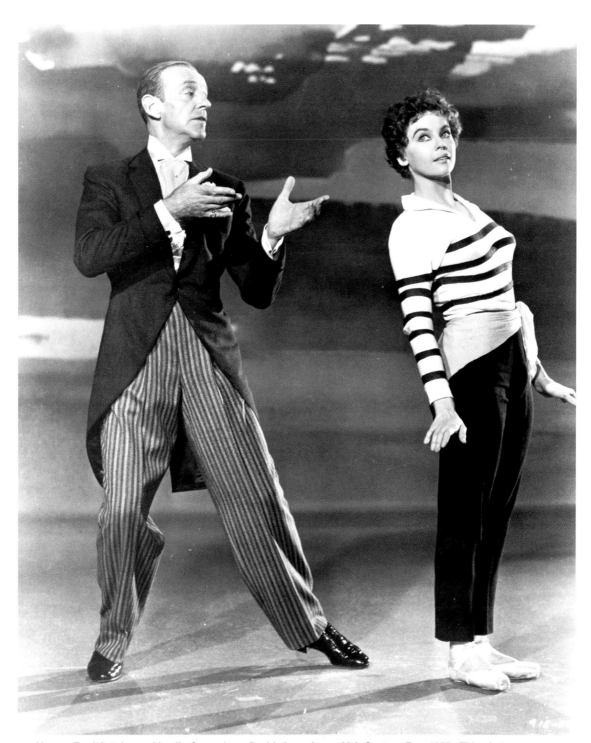

Above: Fred Astaire and Leslie Caron from *Daddy Long Legs*, 20th Century Fox, 1955. This photo was incorporated into some of the film's movie poster artwork. Opposite page: Audrey Hepburn, Bud Fraker, from *Funny Face*, Paramount, 1955. Fred Astaire co-starred in this production with Hepburn. Astaire's character was loosely based on photographer Richard Avedon, who consulted on the film.

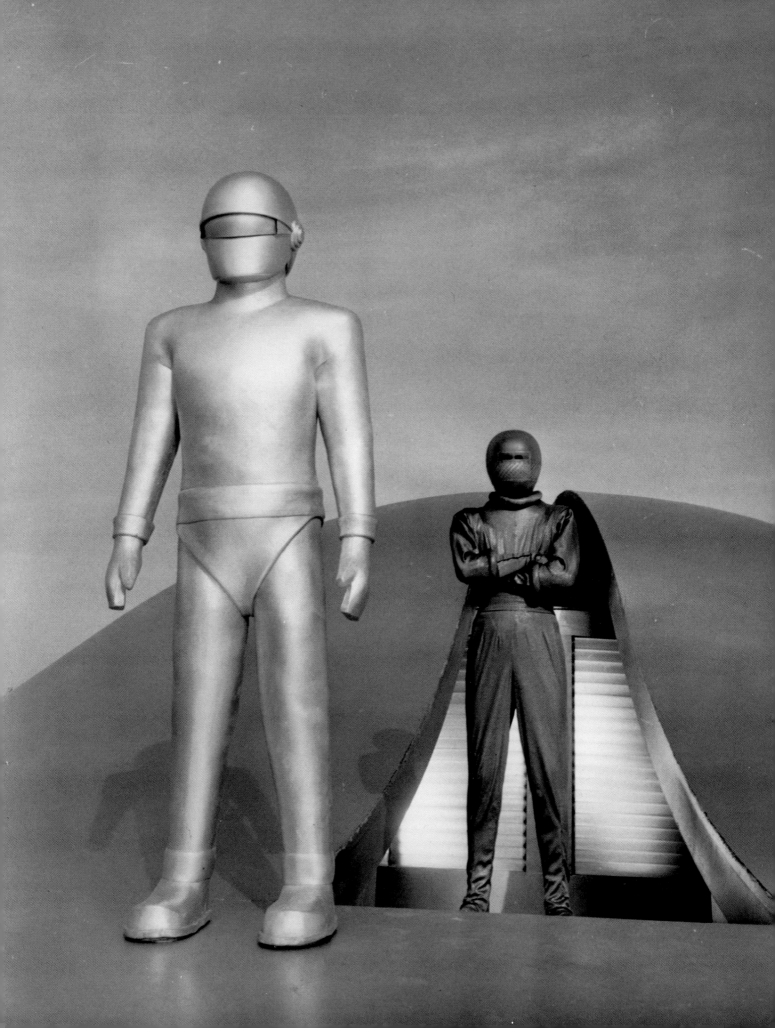

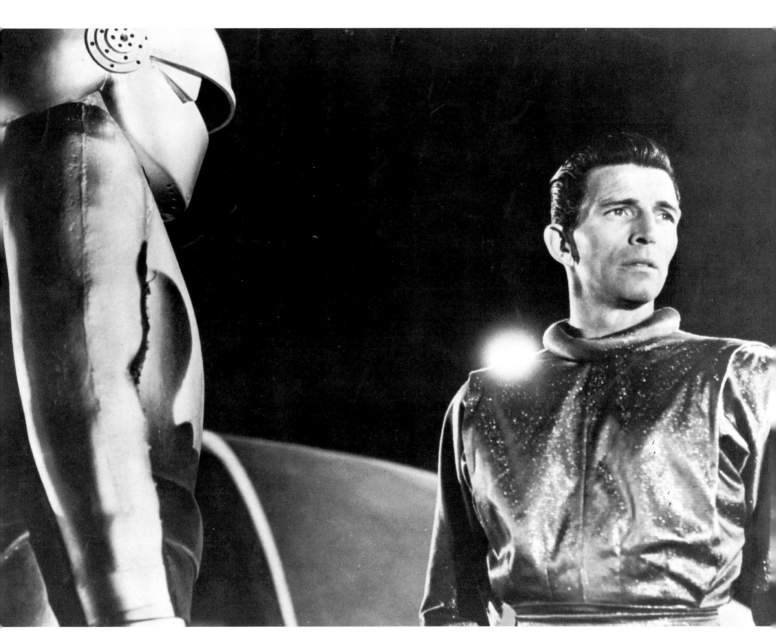

Above and opposite page: Michael Rennie and Gort from *The Day the Earth Stood Still*, 20th Century Fox, 1951.

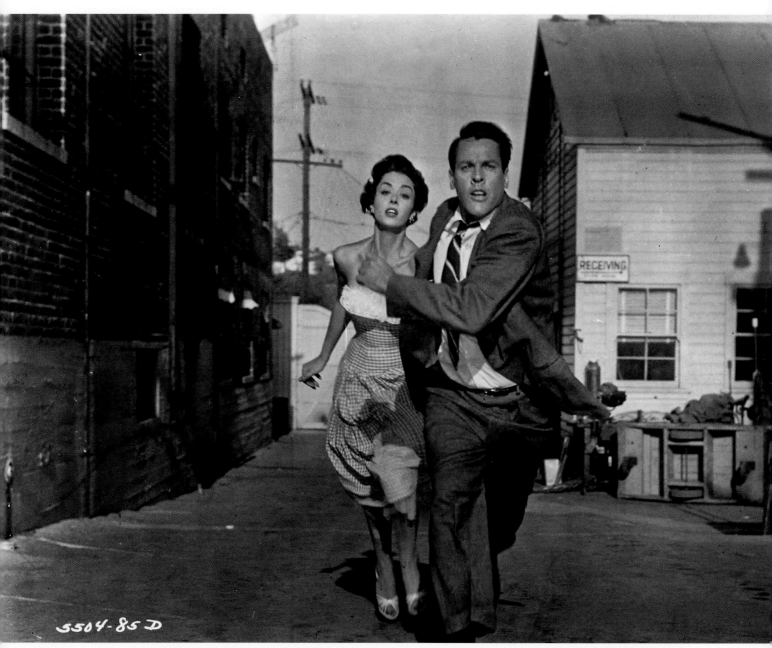

Above: Kevin McCarthy and Dana Wynter run away from the "pod people" in *Invasion of the Body Snatchers*, Allied Artists Pictures, 1956. Opposite page: Joan Crawford from *Johnny Guitar*, Republic Pictures, 1954. Don Siegel's *Invasion of the Body Snatchers* and Nicholas Ray's *Johnny Guitar* both present bizarre archetypes and startling imagery.

1950s: Funny Face and Marilyn; Gort, Sci-fi, and Paranoia; the End of the Studios; and the Times, They Were a Changin'

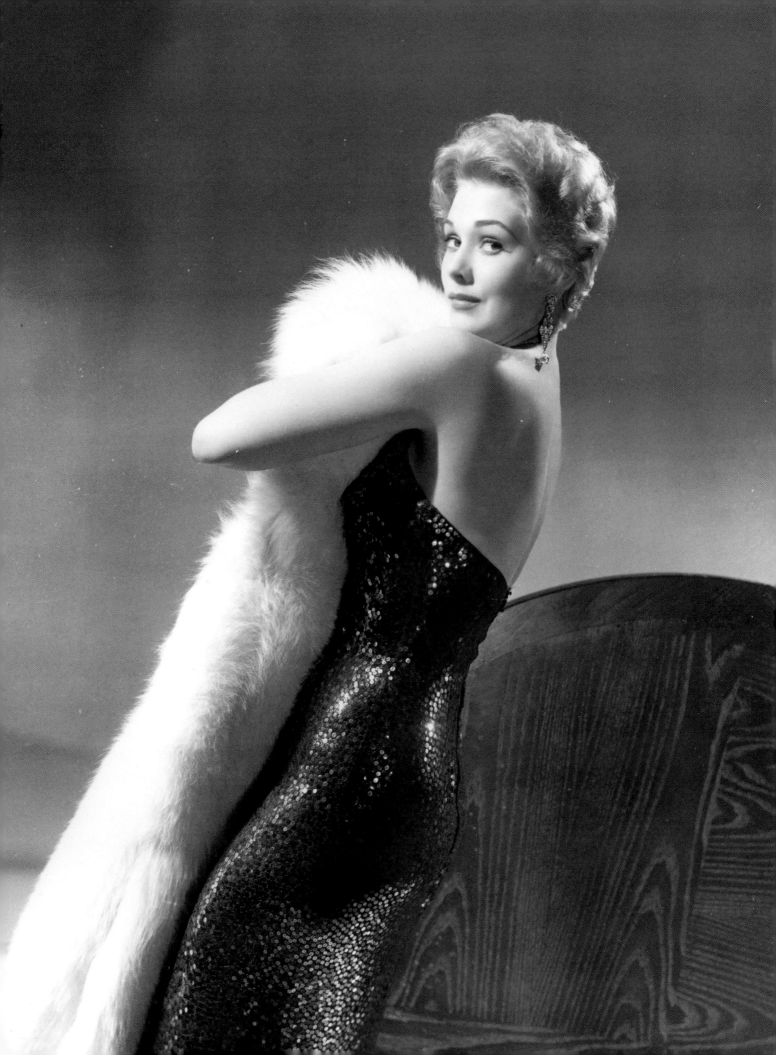

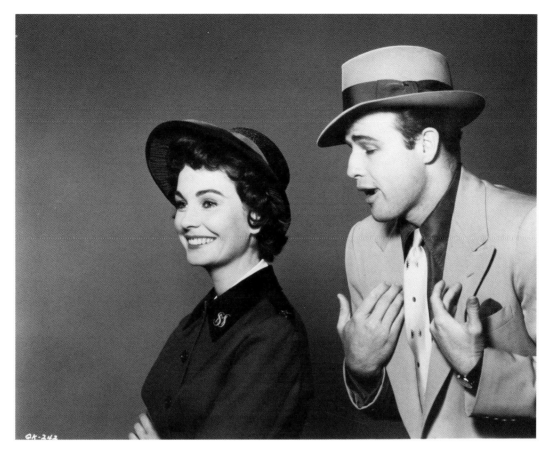

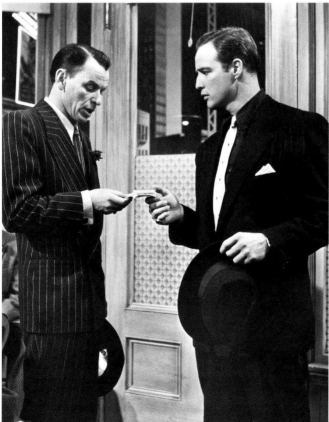

Above and below: Marlon Brando and Jean Simmons and Frank Sinatra and Brando from *Guys and Dolls*, Samuel Goldwyn Company, 1955. Opposite page: Kim Novak from *Pushover*, Columbia, 1954.

Overleaf: Montgomery Clift and Elizabeth Taylor from *A Place in the Sun*, Paramount, 1951.

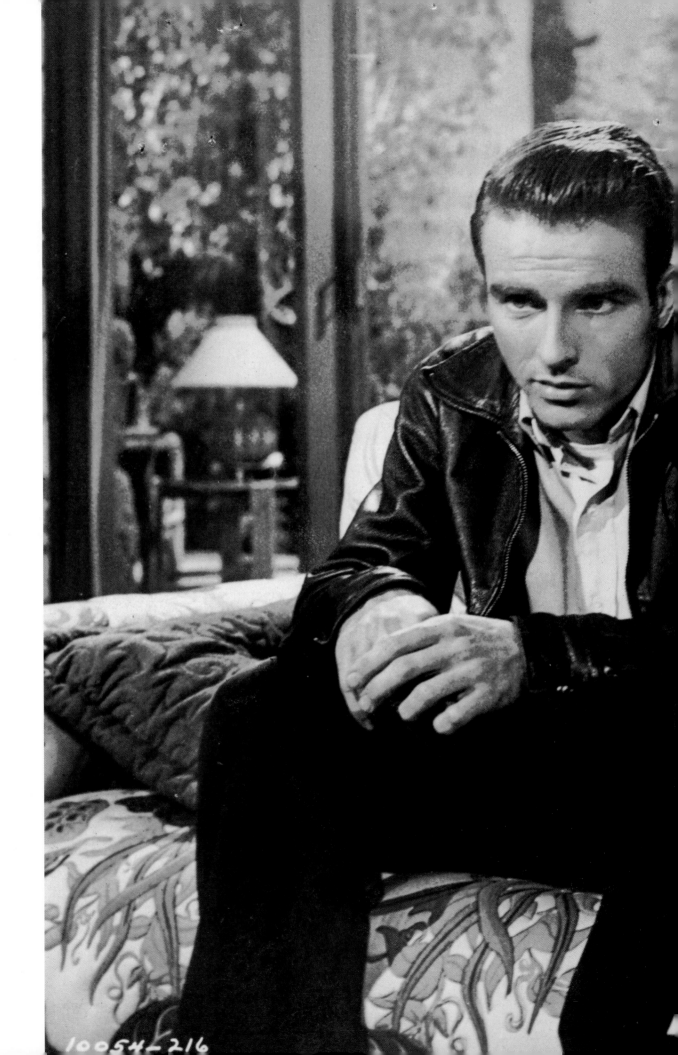

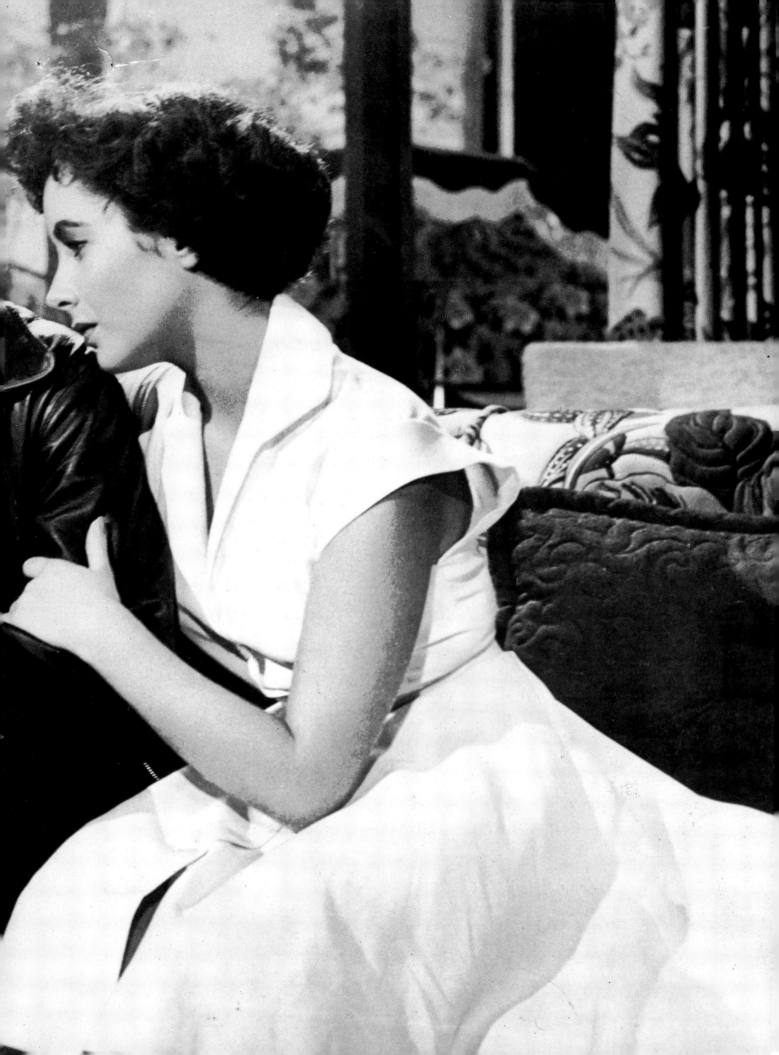

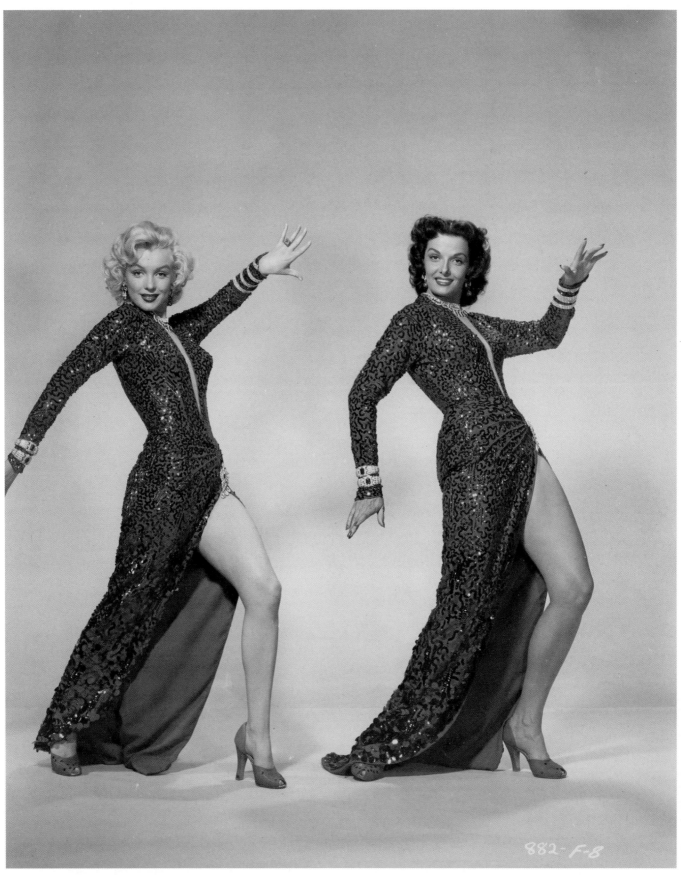

Above: Marilyn Monroe and Jane Russell from *Gentlemen Prefer Blondes*, 20th Century Fox, 1953. Opposite page: Tony Randall and Jane Mansfield from *Will Success Spoil Rock Hunter?*, 20th Century Fox, 1957.

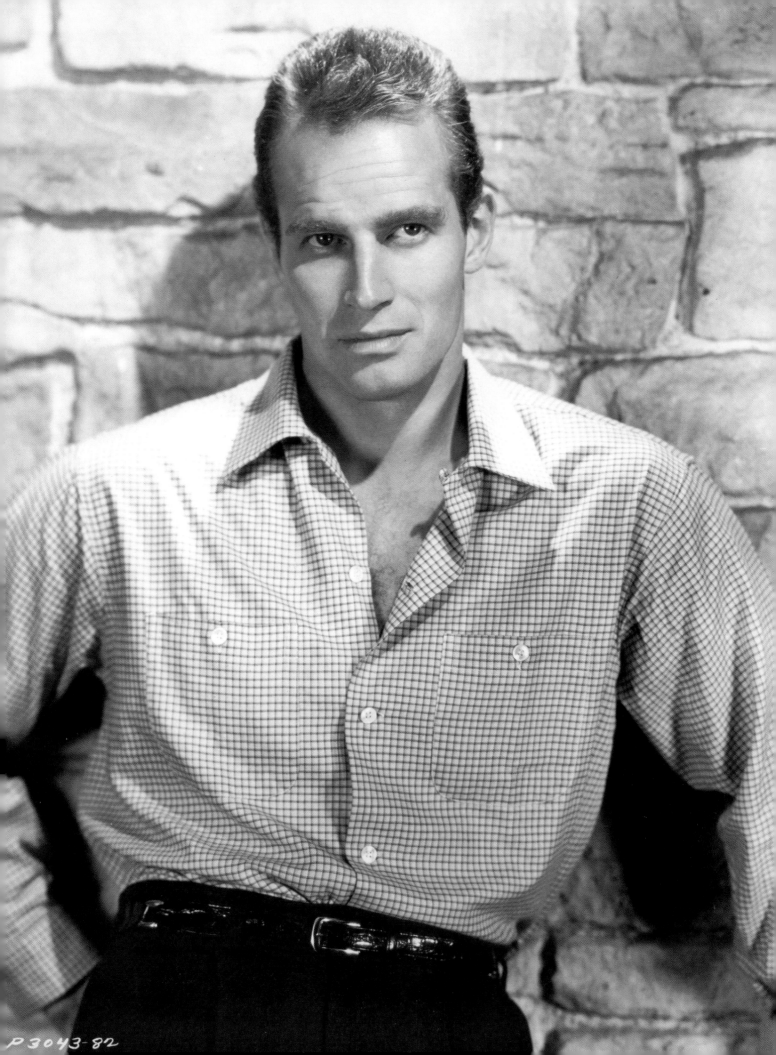

P2878-32

Above: Anne Baxter. **Opposite page:** Charlton Heston, publicity photograph for *The Ten Commandments*, Paramount, 1955.

Above: Ginger Rogers from *Forever Female*, Paramount, 1953. Opposite page: Tuesday Weld.

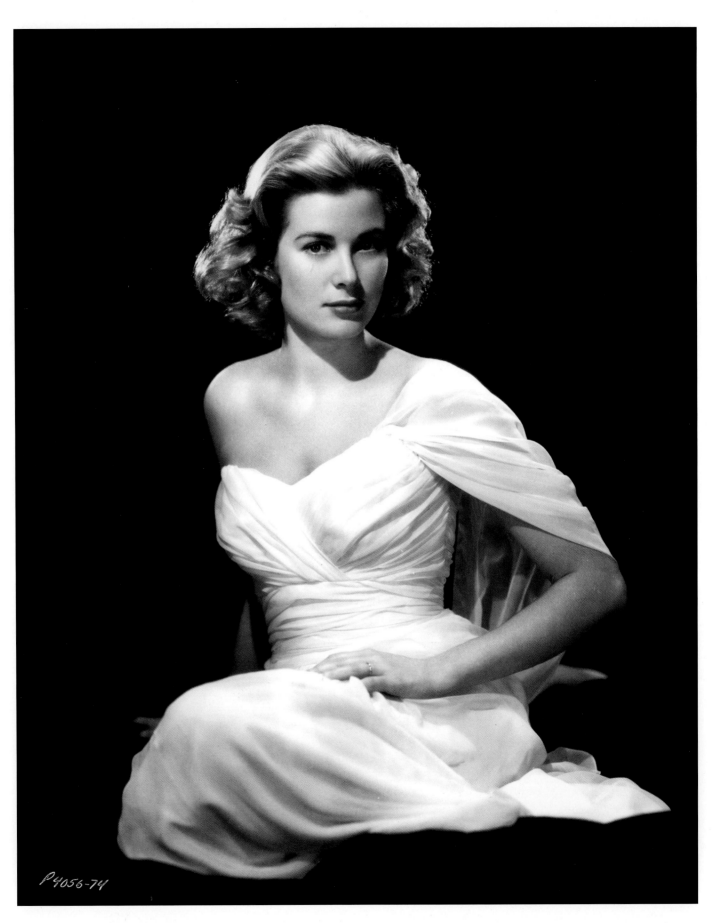

P4056-74

Above and below: Eva Marie Saint, Bud Fraker, from *That Certain Feeling*, Paramount, 1956. Opposite page: Grace Kelly, Bud Fraker.

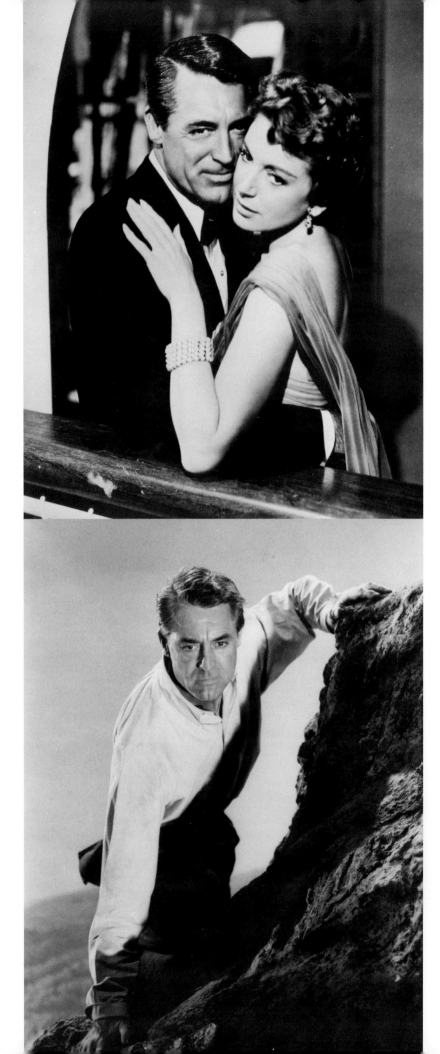

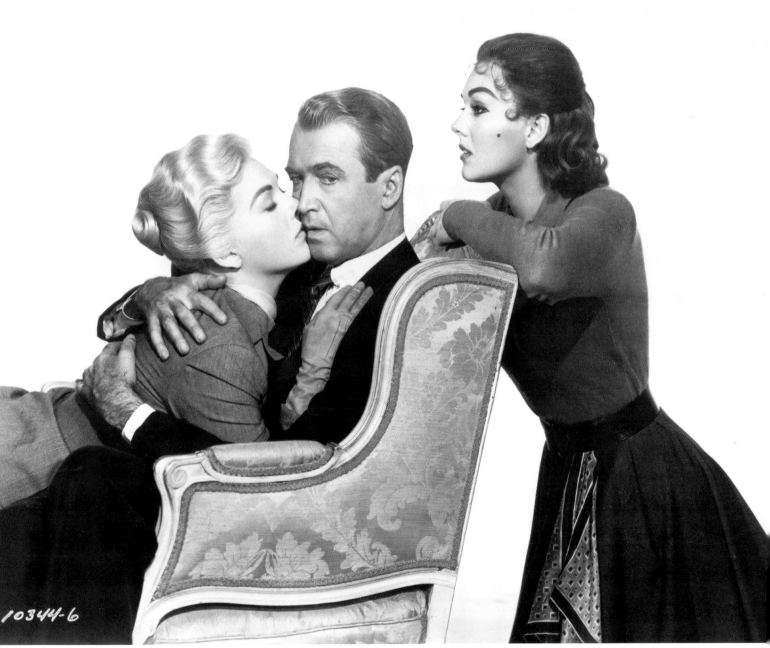

Above: trick shot showing Kim Novak in her "dual role" with Jimmy Stewart from *Vertigo*, Paramount, 1958. This photograph was also used for one of the lobby cards for the film. Opposite page above: Cary Grant and Deborah Kerr from *An Affair to Remember*, 20th Century Fox, 1957. Below: Cary Grant from *North by Northwest*, MGM, 1959.

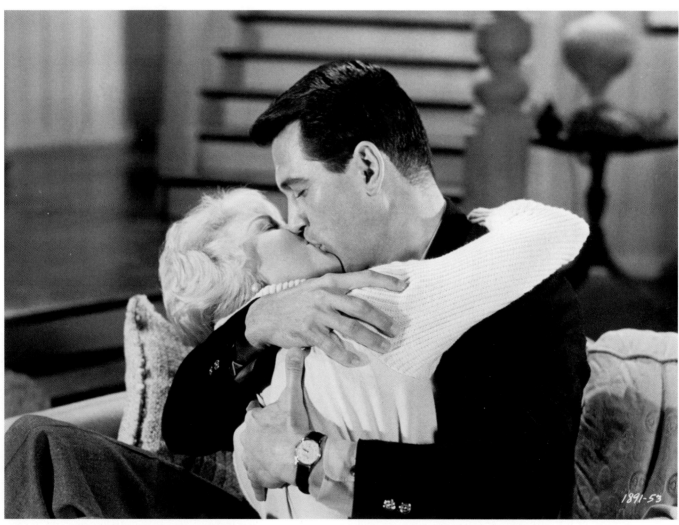

Above: Doris Day and Rock Hudson from *Pillow Talk*, Universal, 1959. Opposite page: Doris Day, Bud Fraker.

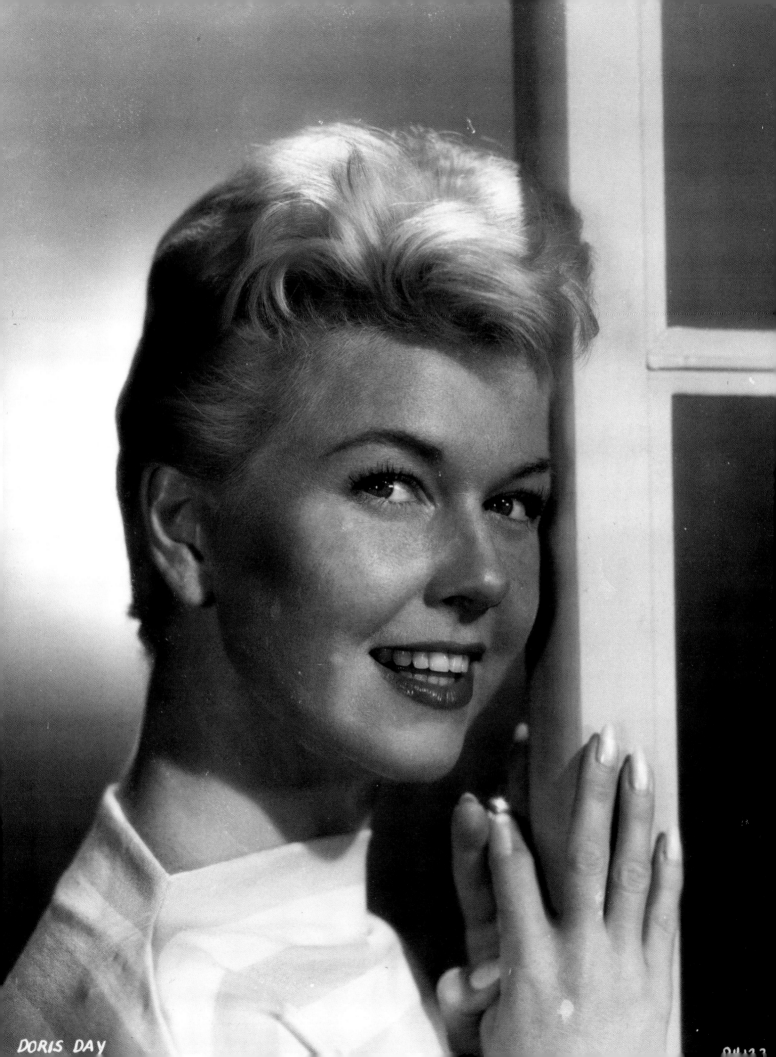

DORIS DAY

C1722-33

Above: Lizabeth Scott. Opposite page: Anne Francis from *The Hired Gun*, MGM, 1957.

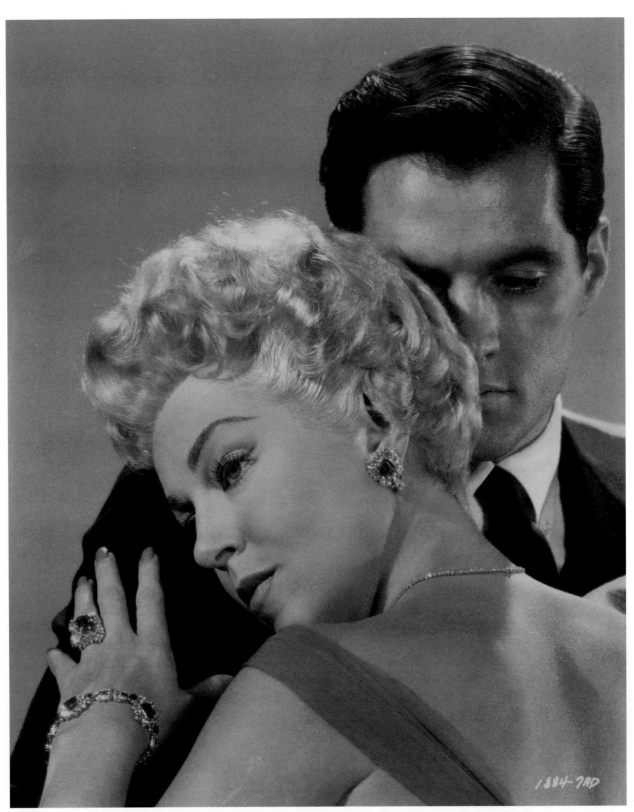

Above: Lana Turner and John Gavin from *Imitation of Life*, Universal, 1959. Opposite page: Barbara Ruick.

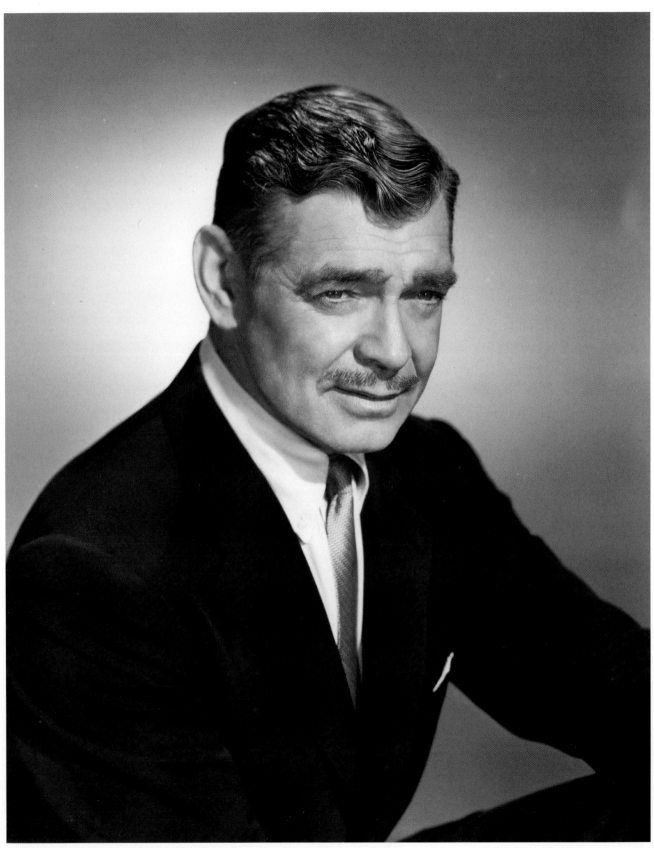

Above: Clark Gable, Bud Fraker, from *Teacher's Pet*, Paramount, 1957. **Opposite page:** Marilyn Monroe from *Let's Make Love*, 20th Century Fox, 1960.

19-74

index

A
A Day at the Races 11,32
Adam's Rib 100
Adventures, Robin Hood 11,42,43
Affair in Trinidad 110,111
Allan, Ted 10,12,14
All That Money Can Buy 55
An Affair to Remember 133
Andrews, Dana 52,78,79
Apger, Virgil 10,104
A Place in the Sun 103,122-3
Ardon, Eve 62-3
Astaire, Fred 6,11,22,23,56,115
As You Desire Me 10,29
A Woman's Face 65

B
Baby Doll 105,113
Bacall, Lauren 51,53,69,70
Bachrach, Ernest 10,11,23,26,51,
 89,104
Baker, Carroll 104,105,113
Barnes, Binnie 21
Baxter, Anne 127
Bennett, Constance 25
Berlin Express 89
Big Sleep, The 51,52,53,70
Blue Dahlia, The 52
Bogart, Humphrey 51,53,68,70,71,72
Brando, Marlon 104,121
Brown, Milton 28
Bruce, Nigel 52,57
Brute Force 53,
Bryan, Jane 36
Bull, Clarence Sinclair 8,9,10,11,13,28,
 29,38-9,104

C
Cagney, Jimmy 15,16-7,103
Carmichael, Hoagy 25,115
Carpenter, Eric 10,98,104
Carroll, Madeleine 49
Casablanca 51
Chandler, Raymond 52
Charlie Chan at Opera 11,47

Christmas Holiday 95
Clift, Montgomery 103,122-3
Coburn, Robert 9,10,11,53,71,74,
 104,105,110,111
Colbert, Claudette 46
Comrade X 53,61,62-3
Crawford, Elizabeth 7
Crawford, Joan 11,45,65,104,
 105,119
Cronenweth, William 93

D
Daddy Long Legs 115
Davis, Bette 11,36,104,105,106
Dark Victory 36
Day, Doris 103,104,134,135
Day the Earth Stood Still 6,103,116,117
Dead Reckoning 53,71
Dean, James 103,104,15,112
Dee, Francis 30
DeHaviland, Olivia 42,43
Destry Rides Again 44
Devil and Daniel Webster 55
Dietrich, Marlene 7,18,44,86
Dishonored 7,18
Donen, Stanley 9
Double Indemnity 52,80-1
Double Weddings 10,38-9
Douglas, Melvyn 28
Down to Earth 92
Dunne, Irene 33
Durbin, Deanna 95
Dyar, Otto 10,20

E
East of Eden 105,112
Engstead, John 10

F
Farewell, My Lovely 52
Flynn, Errol 41,43
Ford, Glen 105,110
Forever Female 128
Fraker, Bud 5,51,104,105,114,
 130,131,135,140
Frank, Nino 52
Francis, Anne 136
Francis, Kay 20
Freulich, Jack 10
From the Barrier 21
Fryer, Elmer 10,42
Funny Face 104,114

G
Gable, Clark 8,10,13,53,61,
 62-3,109,103,104,
 105,140
Garbo, Greta 10,28,29

Gardner, Ava	73,109	
Garfield, James	91	
Garfield, John	6,53	
Gavin, John	104,138	
Gentlemen Prefer Blondes	104,124	
Giant	107	
Glass Key, The	52	
Gort	103,116,117	
Grant, Cary	24,25,26,52,75,104,	
	132	
Grey, Shirley	34	
Guys and Dolls	104,121	

H	Harlow, Jean	10,12,13,14,103
	Hayworth, Rita	92,104,105,110,111
	Hepburn, Audrey	5,102,104,105,114
	Hepburn, Katherine	100
	Heston, Charles	104,126
	High Sierra	51,71
	Hired Gun, The	136
	Hudson, Rock	103,107,134
	Hughes, Mary Beth	36
	Hunt, Marsha	36
	Hurrell, George	9,10,11,36,37,45,
		50,51, 52,59,68,
		84,104
	Huston, Walter	55

I	*I Married a Witch*	84
	Imitation of Life	104,138
	In Name Only	26
	Invasion, Body Snatchers	6,103,118
	I Wanted Wings	52
	It Happened One Night	11

J	*Johnny Guitar*	105,119
	Jones, Jennifer	60
	Jones, Ray	10,73,95,104

K	Kahle, Alex	10,53,67,87,104,
		105,106
	Karloff, Boris	47
	Kelly, Gene	9,99,104,130
	Kerr, Deborah	132
	Key Largo	51
	Killers, The	73

L	Lacy, Madison	9,10,58
	Ladd, Alan	52,82,83,85
	Lady from Shanghai, The	53,93
	Lady in the Lake	53,88
	Lake, Veronica	50,52,84,85
	Lamarr, Hedy	53,61,62-3,96,97

	Lancaster, Burt	53,90
	Lane, Lola	67
	Laura	52,78,79
	Leigh, Janet	101
	Leigh, Vivian	53,66
	Let's Make Love	141
	Lippman, Irving	10,34
	Locket, The	53,87
	Lombard, Carole	4,26,27,74,103,105
	Lone Star	109
	Longworth, Bert	10
	Louise, Anita	36
	Love Letters	60
	Loy, Myrna	10,38-9,40
	Lucky Lady	4
	Lupino, Ida	71

M	MacMurry, Fred	4,52,80-1
	McCarthy, Kevin	103,118
	Magnificent Ambersons	6,53,54
	Maltese Falcon, The	51,52
	Mannequin	45
	Mansfield, Jane	104,125
	Man Who Shot Garbo	10
	Marly, Florence	72
	Marx Brothers	32
	Miehle, John	10,104
	Mitchum, Robert	53,87
	Monroe, Marilyn	103,104,105,
		124,141
	Montgomery, Robert	53,88
	Moorehead, Agnes	6,53,54
	Munkacsi, Mucky	10
	My Man Godfrey	11

N	*Ninotchka*	28
	North by Northwest	104,132
	Notorious	52,75
	Novak, Kim	104,120,133

O	Oberon, Merle	89
	Oland, Warner	47
	Once Upon a Time	75
	O'Sullivan, Maureen	76,77

P	Parker, Jean	21
	Pillow Talk	134
	Postman Rings Twice	6,53,91
	Powell, William	10,38-9
	Powolny, Frank	10,104
	Princess Comes Across	4
	Public, Enemy, The	11,15,16-7
	Pushover	120

R	Rains, Claude	43
	Randall, Tony	104,125
	Rathbone, Basil	43,52,57
	Red Dust	13
	Red Harvest	52
	Rennie, Michael	103,116,117
	Republic Pictures	119
	Richee, Eugene R.	7,9,10,11,18, 30,31,46, 51,52
	Robinson, Edward G.	52
	Rogers, Ginger	23,128
	Ruick, Barbara	139
	Russell, Jane	104,124
	Rutherford, Ann	36
	Ryan, Robert	89
S	*Saigon*	85
	Saint, Eve Marie	104,131
	St. Hilaire, Al	52,75
	Schafer, A.L. "Whitey"	10,11,35,51, 53,64,82, 96, 104,105,108
	Scott, Lizabeth	52,71,137
	Scott, Ned	92
	Shane	52
	Shearer, Norma	11,37
	Sheffield, Johnny	77
	Sheridan, Ann	58,59
	Sidney, Sylvia	19
	Simmons, Jean	104,121
	Sinatra, Frank	104,121
	Sinclair, Clarence	51
	Six, Bert	10,71,104,105,112
	Stagecoach	48
	Stanwyck, Barbara	64
	Stewart, Jimmy	44,104,133
	Sullivan's Travels	52
	Suzy	14
T	Taylor, Elizabeth	98,103,107,122-3
	Taylor, Robert	40,53,66
	Tarzan's Adventure	77
	Teacher's Pet	140
	Ten Commandments, The	126
	That Certain Feeling	131
	These Glamour Girls	36
	Thin Man, The	11
	This Gun For Hire	52,83
	Three Stooges	94
	Tierney, Gene	52,78,79,104, 105,108
	To Be or Not To Be	74
	Tokyo Joe	72
	Tone, Frachot	14

	Top Hat	11,23
	To Have and Have Not	51
	Topper	11,25
	Tracy, Spencer	11,45,100
	Trevor, Claire	48
	Turner, Lana	6,36,53,90,104,138
V	Veidt, Conrad	65
	Vertigo	104,133
	Voice of Terror	52
W	Walling, William	10
	Waterloo Bridge	66
	Wayne, John	48
	Waterloo Bridge	53
	Webb, Clifton	52,78
	Weissmuller, Johnny	77
	Welbourne, Scotty	10,15,27,41
	Weld, Tuesday	105,129
	Welles, Orson	53, 93
	West, Mae	31
	Wife vs. Secretary	10,13
	Willinger, Laszlo	10,11,40,45,53,66
	Woods, Edward	15,16-7
	Wray, Fay	35
	Wynter, Dana	118